D0046179

NO LONGER PROPERTY OF
ANYTHINK LIBRARIES/
RANGEVIEW LIBRARY DISTRICT

365 gratefuls

CELEBRATING TREASURES, BIG AND SMALL

NO LONGER PROPERTY OF
ANYTHINK LIBRARIES/
RANGEVIEW LIBRARY DISTRICT

HAILEY & ANDREW BARTHOLOMEW

A PERIGEE BOOK

A PERIGEE BOOK
Published by the Penguin Group
Penguin Group (USA) Inc.
375 Hudson Street, New York, New York 10014, USA

USA / Canada / UK / Ireland / Australia / New Zealand / India / South Africa / China

Penguin Books Ltd., Registered Offices: 80 Strand, London WC2R 0RL, England
For more information about the Penguin Group, visit penguin.com.

365 GRATEFULS

Copyright © 2013 by Hailey Bartholomew
All rights reserved. No part of this book may be reproduced, scanned, or distributed in any printed or
electronic form without permission. Please do not participate in or encourage piracy of copyrighted
materials in violation of the author's rights. Purchase only authorized editions.
PERIGEE is a registered trademark of Penguin Group (USA) Inc.
The "P" design is a trademark belonging to Penguin Group (USA) Inc.

ISBN: 978-0-399-16118-6

First edition: April 2013

PRINTED IN THE UNITED STATES OF AMERICA

10 9 8 7 6 5 4 3 2 1

While the author has made every effort to provide accurate telephone numbers, Internet addresses, and
other contact information at the time of publication, neither the publisher nor the author assumes any
responsibility for errors, or for changes that occur after publication. Further, the publisher does not have
any control over and does not assume any responsibility for author or third-party websites or their content.

Most Perigee books are available at special quantity discounts for bulk purchases for sales
promotions, premiums, fund-raising, or educational use. Special books, or book excerpts,
can also be created to fit specific needs. For details, write: Special Markets, Penguin
Group (USA) Inc., 375 Hudson Street, New York, New York 10014.

The Story of *365 Gratefuls*

Back in 2008, I was feeling depressed and incredibly out of sorts with life. At the time, I wrote this in my journal:

A restlessness and dissatisfaction with life has been haunting me. I am tired all the time. Though I love the kids, I feel lost—so lost— and bored too. What is it all for—live, work, grow old, and die… what for, anyway?

I want more than this. I want to be alive. Even though I am living, my soul feels numb and dead, and little things bother me, and I have no peace. I know in my head my kids are amazing and important, and I love them, yet I feel little during the day and lack patience.

My heart is far away, and the kids cling to me because of this. I see endless piles of washing and dishes and housecleaning that return as soon as I turn around. My heart is missing the point, and there is no meaning in this suburban life. I love my partner but he doesn't understand me. I cling to him for fear of the feelings that swim in me— the thoughts of death and the pointlessness that claw at my back. His contentment seems like a slap in the face to how I feel. I feel a wall between us… My neediness makes me dislike myself even more.

Not long after this diary entry I realized I needed to see someone.

I had heard about a nun who did life coaching and counseling. The idea of seeing someone with a totally different perspective on life—someone spiritual, wise, and totally separated from my ordinary life—entranced me. Sister Paula was all this and more.

She sat and patiently listened to my confused ramble about life. Finally, with great wisdom, she shared her secret to happiness. According to Sister Paula, finding happiness was all about reflection and gratitude. She asked me to try it out each night—to reflect on my day and then write something about that day that I was grateful for. She told me to be honest—not just listing the things I knew I should be grateful for, but rather to reflect and feel. So I did.

Three nights into this practice, I was sitting on my bed writing, and a realization hit me with such force: If I had not been hunting for these little moments each day, I would not have seen them. What else was I missing?

I began to take the project more seriously. Being a photographer, I thought that rather than write down my discoveries, it would be more natural for me to take a photo a day. I bought a beautiful red leather album and ordered enough Polaroid film to see me through a year—and lucky I did!

It amazed me how quickly I began to notice more and more "gratefuls." It was not long before it was hard to take only a single photo each day.

One of the first things I noticed was how amazing my husband really was—I had been thinking he was very unromantic! Yet the longer I did the project, the more I saw all the little ways he cared and thought of me. One night as Andrew served dinner, I realized I had not taken a grateful photo yet. I looked around my house, and as I did, I noticed Andrew serving dinner. He was serving me the biggest and best piece of pie, while giving himself the smaller, weird-looking one! I felt I could cry with gratitude. In that moment, I had such a sense of what I had been missing—all these little gifts conveying love.

Through taking the pictures, I also began to connect with nature in a way I never had before. It felt like all the pretty flowers and even weeds blowing in the wind were treasures just for me.

The consequence of feeling like life is actually amazing is that you start to believe you have something to give the world. You feel full, and it spills out all over the place. I decided to share my Polaroid 365 Grateful project on Flickr. From there a group was formed, and hundreds of others began their own versions of the project. The idea was

Acknowledgments

spread through articles in the Australian magazines *Frankie* and *Notebook*. Readers responded in large numbers to the stories.

One of the most humbling and beautiful responses to the project was an email from Amy Gill. Amy's letter made me realize that gratitude was powerful not just for everyday living, but even for making it through the toughest circumstances life can throw at you. You can read her story on the following pages.

Today, I am grateful to be alive, really alive, which brings me to this book. *365 Gratefuls* started out as a photography book of all the images from my Polaroid 365 Grateful project. But after seeing and reading so many amazing images and stories from others who were inspired to begin their own projects, I felt it would be wonderful to include some of these in this book. So now I have the honor of sharing some of my images alongside beautiful photos by many amazing people who kindly contributed their stories or grateful moments. My hope is that, as you take a look at the amazing power of gratitude, you will be encouraged to find gratefulness, and that you will be left with something wonderful to take on your journey.

A very special thanks to all the truly beautiful people who have kindly shared their thoughts and photos and artwork. I feel honored to have so much good company in this book! It is humbling how many people so willingly shared their talents and time to help be part of this project. I am grateful. I am honored. Thank you to Janelle Glickman and Charles Shaughnessy for your invaluable contributions. Thanks to Roweena Timson for your unceasing support and to Patrick Dodson for all your hard work.

A most special thanks to Andrew for loving me so unconditionally. It is in your unconditional love that I have flourished and had the space to make all these discoveries.

A special thanks to my two beautiful girls, Zali and Poppy. You are the catalyst for so much of my growing up. I am eternally grateful to you for all that you teach me and all the gifts you have given and continue to give me. My sweet muses, thank you! I am grateful to be your mama.

And finally to Amy Gill for inspiring me to make something BIGGER of all this. For your honesty and for your bravery. You have been such an amazing inspiration to me. Thank you!

Amy's Story

Grateful hasn't always been part of who I am.

I used to view the world very differently. I wasn't ungrateful, but I saw the good things as good and the bad things as bad, and that was that. Then something changed in me. Something big.

Three years ago today, I was sitting in neonatal intensive care holding my baby girl Rosie, only twenty-three days old and weighing no more than 3 pounds, 5 ounces. She was tiny and precious and perfect, except for her broken heart—a heart that would never be able to mend. As I held her on this day I could feel her slipping away, finding it harder to fight. Twenty-four hours later she was gone and so was a part of me.

The day after she died I woke to the crying of her twin sister, Penny, beside me. I wasn't sure how I was going to get out of bed and face the world. The crying became more persistent. I lifted Penny into my arms and began to feed her, and suddenly I was overwhelmed with gratitude. I grabbed hold of this gratitude and clung to it like a life rope.

The day of Rosie's funeral we released twenty-four butterflies into the sky to say goodbye, one for each day of her short life. With these butterflies I also released my anger, hurt, pain, and regret, and it was at this moment that I took the first photo in my 365 Grateful project (right). This is when my life changed.

As I took each photo I began to notice that the good things in my life weren't just good, they were AMAZING, and the bad things weren't all so bad. With each photo I began to heal, and gratitude became a way of life.

I look back on the loss of my baby girl, and no longer do I see the pain; I only see the blessings. I got the chance to hold my Rosie, tell her I love her, introduce her to her sisters, bathe her, feed her, spend time with her, and most of all, learn life's biggest lessons from her… and I am grateful.

AMY GILL

I like rain—it brings out the umbrellas!

HAILEY

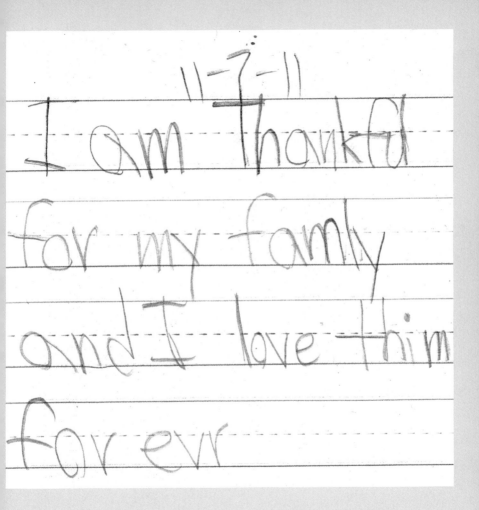

I am "-7-11 Thankful
for my famly
and I love him
for evr

RYDER SCHWEDHELM

SIMPLY

BECOME HOO

YOU ARE

Grateful for magical gifts from my children.

DEB SCHWEDHELM

I lifted her up to the top step and she turned
and offered her little hand.

HAILEY

My little nephew Zen with his bear hat.

HAILEY

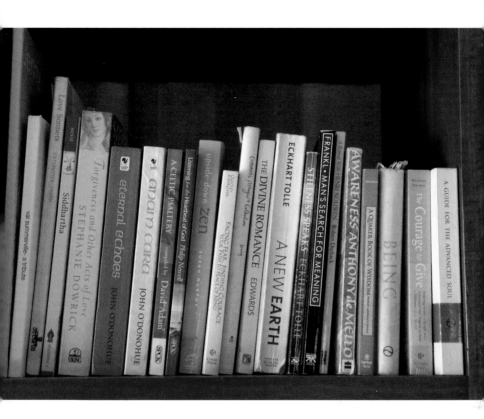

I am grateful that men and women over the ages
have shared their wisdom so that all may benefit.

ISABELLA CHRISTINE ERSKINE-SMITH

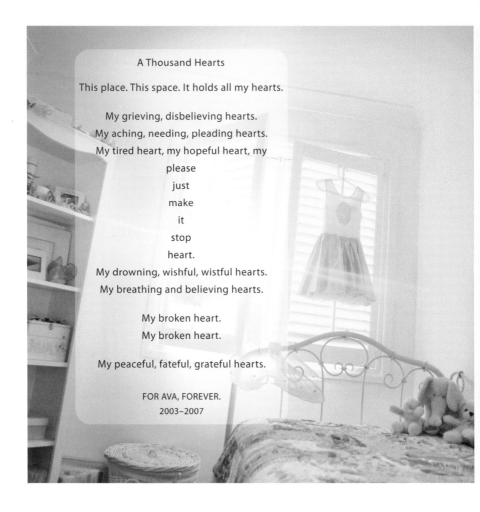

A Thousand Hearts

This place. This space. It holds all my hearts.

My grieving, disbelieving hearts.
My aching, needing, pleading hearts.
My tired heart, my hopeful heart, my
please
just
make
it
stop
heart.
My drowning, wishful, wistful hearts.
My breathing and believing hearts.

My broken heart.
My broken heart.

My peaceful, fateful, grateful hearts.

FOR AVA, FOREVER.
2003–2007

SHEYE ROSEMEYER

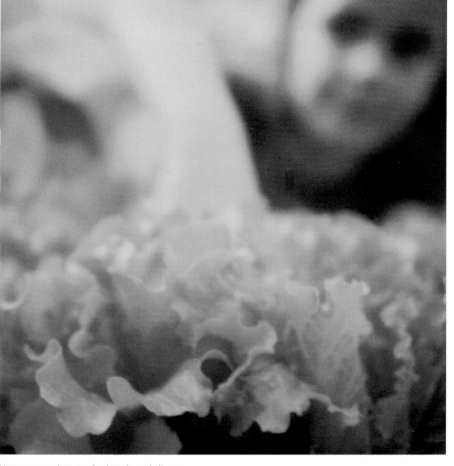

Homegrown lettuce for lunch and dinner.

HAILEY

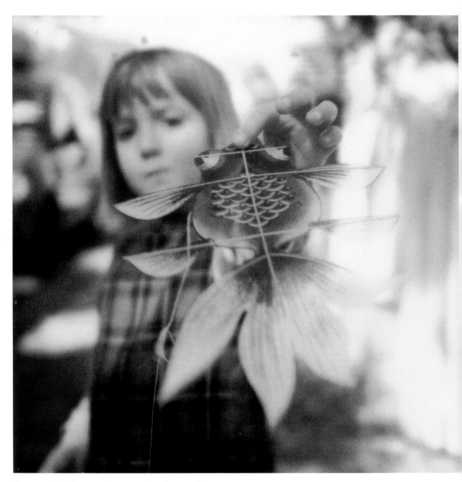

Flying a little kite in the most lovely weather.

HAILEY

I am grateful for Kyle.

He is my best friend and my husband. Every day we spend together is an adventure and I am a better person because he is in my life.

Our relationship fills me with energy and makes me feel alive. I am one lucky lady.

This is a watercolor I painted of him.

MADILYNE MALONE

by Leah

When my two girls were little we had a standing joke. I liked to tell them that I (Dad) was in charge of the family. They would just smile and remind me it was actually Mum. They said I might be the head, but Mum was the neck that turned the head. Then one day, six-year-old Leah presented us with her latest picture, a portrait of her mum and dad. No words, just a twinkle in her eye. I am so grateful for the humor of little children.

DOUG SINDEL

Every day for a week these have been on my front step
making me happy and grateful.

HAILEY

These guys have been rocking in their eggs for a whole day.
The excitement is building!

HAILEY

Some years ago I had a soul-destroying job cleaning three hundred dormitory rooms for well-to-do university boys, knocking on every door calling out "Cleaning!" Despite my attempts to chat I just got blank, condescending looks from the young men; I felt worthless.

Then one Friday morning I was so grateful for a young man with simple good manners. I knocked on his door—"Cleaning," I said.

I pulled the mop out of the bucket—sweat pouring down my face—expecting another blank, condescending look. Instead I heard "Hi! My name's Michael. What's your name?" With those simple polite words I felt human again.

As he was a well-respected young man at the dormitory, his actions seemed to have a secondary effect. Over the following days, as the other boys saw Michael stop to have little chats with me, others became more polite, saying hi and remembering my name.

Now I have another job, but every time I walk past a cleaner or busboy in the shops I stop and have polite small talk. They are grateful for the respect! I am so grateful good manners can change someone's day.

BELINDA WHITEHOUSE

I am grateful for the clouds in the sky… especially when they look like this.

RIKKI REID

Henna tattoos.

HAILEY

They arrived safely... too cute for words.

HAILEY

I am grateful that the last day I spent with my grandma was an amazing one.

January of this year my grandma suffered two massive heart attacks and was hospitalized for over a month. At the time she was admitted to the hospital the doctors told us that she more than likely wouldn't make it because she'd been deprived of oxygen for too long and was pretty much brain-dead. My grandma was my best friend so naturally I didn't take the news well. I spent the month that she was in the hospital thinking of all the things I could've done or should've said. A couple days before her funeral I decided to wander around and take some pictures to get my mind off things. As I was uploading my new pictures I stumbled upon some photos I'd taken mere hours before she fell ill and they brought back so many memories from that day.

The morning before she got sick, I bought a new camera, and I was so excited that I took about one hundred pictures. My grandma, being the sweet lady that she was, asked to see some of them because she knew how excited I was to show off. So that afternoon I crawled into my grandma's twin-size bed with her and we went through all my pictures and talked and laughed for ages.

Looking back at that day made me forget all the regrets I'd spent so much time focusing on and realize that even though she was dead, she wasn't gone. I still had all my wonderful memories of her, photographs, and I was even given her favorite gold cross to wear so I'd always have a piece of her.

Even though all we did was lie in bed and talk and whatnot, that day still means the world to me because it allows me to take solace in the fact that her last hours were spent with someone who loved her more than life itself. It still hurts every day that I wake up and she's not here, but the memory of that day, along with all the other good memories I have of her, make it easier to live without her. I'm so grateful for that day and all these memories because they allow me to keep a little piece of her forever.

JESSICA JEWETT

Is it possible to be grateful for earthquakes? These massive forces of nature that destroyed so much around me? That took away a friend—a loving, loyal family man—leaving behind a grieving wife and two gorgeous children? That frightened my children in ways that I never want to see again? That damaged my home, and those of my friends, many beyond repair? That took away most of my tight-knit community's infrastructure, but not the community's strong spirit? That were so numerous we became used to living with the fear?

The 2010–2011 earthquakes in Christchurch, New Zealand, were life-changing for my family and me. February 22 was a devastating day for so many. Another large shake in June inflicted significant structural and cosmetic damage to our house in Lyttelton. After an almost equally large shake in December, I saw a change in my six-year-old son's behavior. He began to have nightmares, and other signs of anxiety appeared. It was awful to see him suffering, and I felt it wasn't fair to put him or his younger sister through any more. So a few months later, we left and moved back to my homeland of Australia, and into the hinterland of Byron Bay.

After arriving here we felt such relief! Such happiness! As the reality of our new environment

set in, we really couldn't believe how lucky we were. Despite arriving at a time when the region was experiencing extraordinarily high rainfall, we were ecstatic at the simple things . . . the sun (when it peeped through the clouds on the odd occasion), the birds, the sea, the warmth, the stability of the land. How many times did my husband and I state how happy we were? I lost count! We were really celebrating life after eighteen months of stressful and sometimes life-threatening events. People in our new town amused us with their everyday worries—just the sorts of things we would have been stressed about before the quakes. But now we realize these worries really are "small stuff" and are not worth sweating! Sure, they still exist (ours usually revolve around money, time, and housework), but I take a different approach now. They don't work me up as much as they used to—they are just a part of life and need to be dealt with to allow ourselves to get on with the good stuff, the fun stuff!

I am grateful for the earthquakes. They shook me out of the rut I was in. I now see what is in front of me, and that life is precious and short, so I might as well get on with living it the way I want to. I know it's up to me, so now I'm making it happen.

VICKI MARTIN

New blue pot for favorite succulent. So surprised and
delighted by gardening... I am grateful for green!

HAILEY

Change of season. My favorite from a tree on our street.

HAILEY

Eight years ago, he came on an exchange program to spend the summer with my family. Now he lives with us, and he is my brother from Western Sahara! He is a lesson in what you really need in life, and I am happy that he has a future to look forward to.

MARIA LOPEZ

Every time I see a ladybug, I think of my grandmother. I was terrified of them, and she finally talked me into holding one. She told me she thought they were beautiful when they were in the air. I never saw one flying until the other day, and I managed to take a picture of it.

This is for you, Gram.

ALLISON LEACH

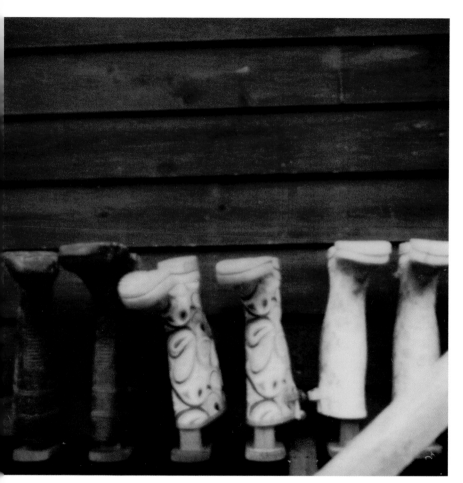

...Mum and Dad's property and running around in big rain boots.

—HAILEY

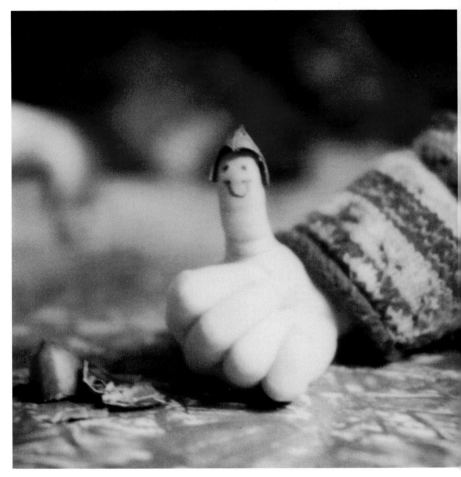

Pecans are yum and fun.

HAILEY

And then sometimes, I am just grateful that the sky sits beside me like my best friend, to watch the world function and go by below us, never letting me be lonely.

TUHINA TOMAR

Autumn. The light soft, mysterious, mellow, the smell of woodsmoke, the early twilight. Soothing. Enveloping. Protective. And it somehow reminds me of my much loved childhood in a way that nothing else does.

JULIE RENOUF

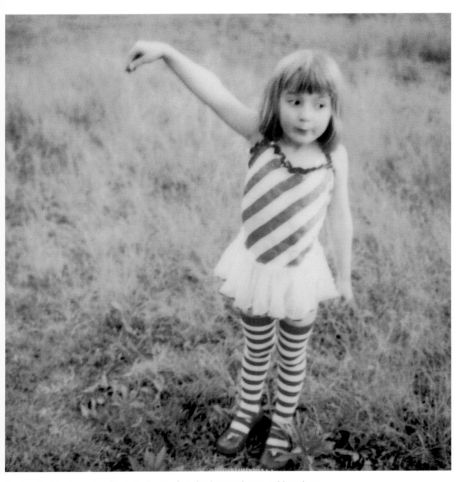

Pretending to be a candy cane. Every day she brings love and laughter.

HAILEY

Finding love all around.

HAILEY

I'M grateful FOR MY BEAUTIFUL FAMILY

NATALA STUETZ

Small, beautiful things that make me smile.

HAILEY

Grateful for love and the peace of mind knowing our
loved one is still with us even if we can't see her.

HAYLEY JONES

Grateful to have these boys and these moments.
Grateful to know that I want what I have.

AUTUMN SPROLES

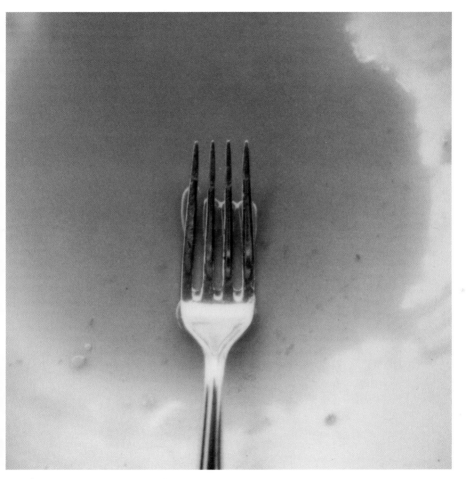

Breakfast with dear friends—beautiful day.
Pancakes with loads of syrup.

HAILEY

Photos can jump-start a cascade of fond and tender memories and details. This photo of me and my mom, taken by my dad, reminds me of my childhood and how grateful I am for my family.

MARY DE CICCO

I love making "land art" in the forest or on the beach. It makes me happy to know that when people go by and see the creative things I have made, they will walk away with happy smiles on their faces.

MARIANNE ANDERSEN

Fuzzy newborn foal ears.

PETA MAZEY

I love market day. Whole bunch of flowers for $2.10. Four new pieces of clothing for $8!

HAILEY

The way he reaches over while driving,
squeezes my hand, and says "I love you!"
HAILEY

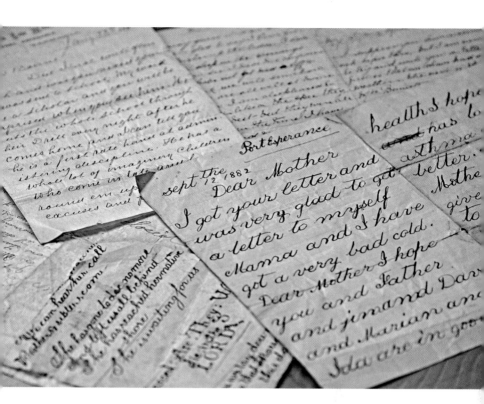

I inherited these gems of history from my mother. Born in 1874, my grandfather was one of twelve children, and when he was six was "adopted out" to family friends. This letter, written in 1882, was his first in his own handwriting. I love the beauty of the language, the heartfelt cry of a little boy trying to be brave—and the neatness of his eight-year-old writing. I am grateful for this link to my past and for the memories it creates.

ISABELLA CHRISTINE ERSKINE-SMITH

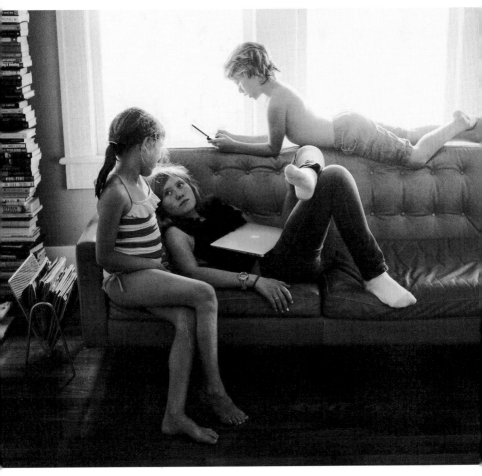

Grateful for the memories.

DEB SCHWEDHELM

We were about to celebrate my grandfather's eightieth birthday in our garden, knowing it would be his last because he was dying of cancer. My youngest son, who was six years old at the time, had been watching the news all week, along with the rest of the family, learning all about the terrorist attack in Oslo, only a few minutes away from our home.

For some reason he was scared that his great-grandfather's party would be canceled because of all the devastating news. He went outside for a while and when he came back in he told all the guests not to worry about anything, because he knew how to keep the terrorists off our property! He told us that he had built a catapult that would keep all enemies out. We all went outside to see, and my grandfather laughed so hard his teeth fell out. The memory of that smile makes me so grateful.

I held my grandfather's hand when he passed away in November, while remembering the smile he had on his face a few months earlier. All because of one very brave little boy, his love for his great-grandfather, and his catapult!

(And no… it is not a regular-sized soccer ball).

JANNE NORDVANG

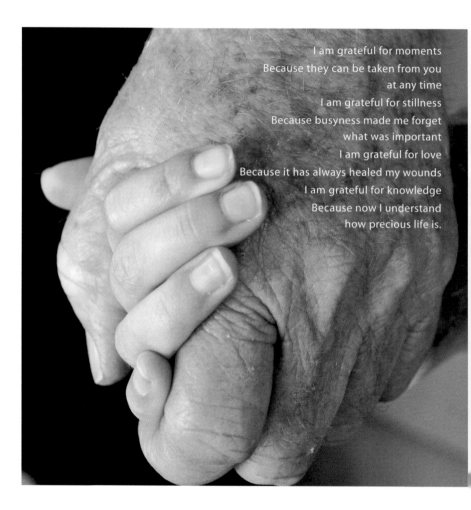

I am grateful for moments
Because they can be taken from you
at any time
I am grateful for stillness
Because busyness made me forget
what was important
I am grateful for love
Because it has always healed my wounds
I am grateful for knowledge
Because now I understand
how precious life is.

KAREN LANG

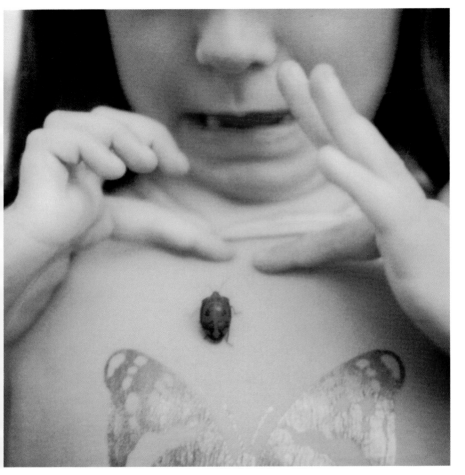

An amazing beetle flew into our lives… so colorful.
He let me photograph him for ages!

HAILEY

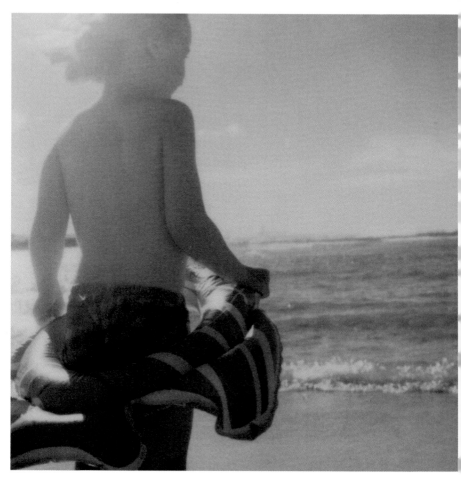

Autumn is warm enough for swimming in your undies!
I am thankful to live here.

HAILEY

I am an eleven-year-old girl, and I live in China. I am taking a ballet class here in Suzhou (the city where I live).

I'm grateful for the way my ballet shoes fly across the floor when I dance. I love the way full tutus fit and the way you can dance in them so easily. I love the feeling when you are about to go onstage for your first-ever ballet recital.

ELISABETH JONES

The way you feel so important when you dance, and how you never want to stop. I love watching ballerinas dance in shows. And wishing I could be one of them…

I'm hoping I can be a professional dancer when I grow up. I want to be in the *Nutcracker*. I would really like to go *en pointe* someday.

I couldn't believe that the day after surgery for oral cancer, with a piece of my tongue missing, I was able to put food in my mouth and attempt to chew. To me it was a miracle. An amazing moment. Realizing that from here on it can only get better and improve!

RIVKA FARCAS

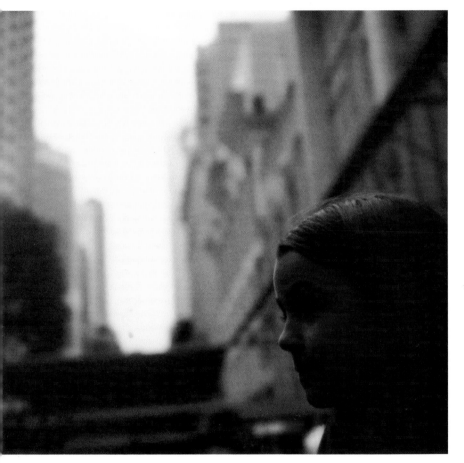

In the big city with my little big girl.

HAILEY

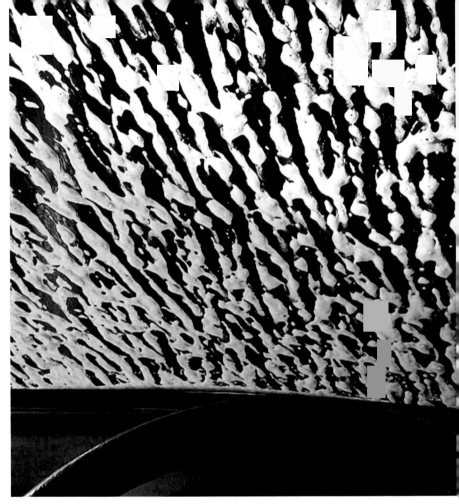

I love going through the car wash and being able to close myself away from this crazy little world for a moment. Grateful for a few minutes of peace, quiet, and bubbles.

EILEEN-RITA FOLWELL

A moment of silence to remember the many victims.
Maybe our gratitude for life will change the way we live today.

KERSTIN KRAUSE

I'm glad to be grateful for the little things in life each day and
to have a daily goal to always be in search of these things.

NANCY ROBISON

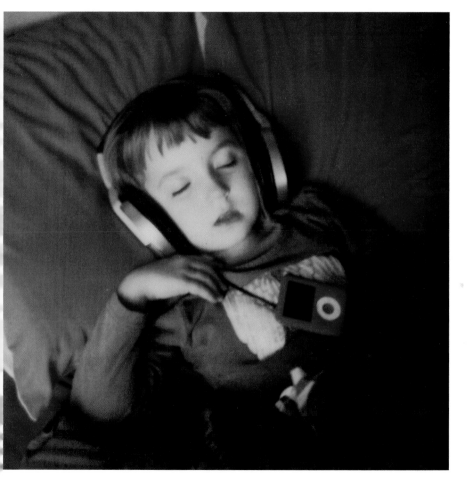

Sick and raining. Still, perfect moments all around.

HAILEY

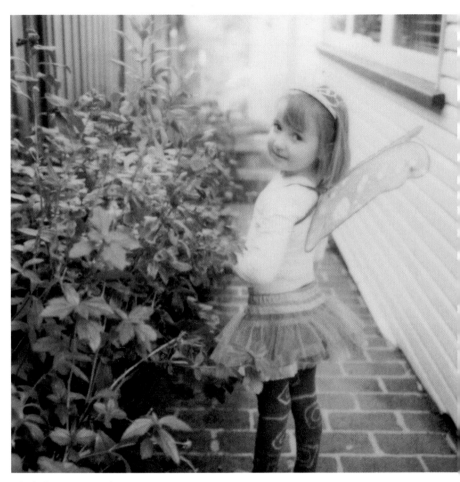

A little fairy in my garden.

HAILEY

When I moved in to my new home, much of the garden was full of blackberries and onion weed. A neighbor helped me weed and dig out all the blackberries, and another arrived unexpectedly with cuttings and seeds. That was last autumn.

This autumn the bed is a mass of flowers of white and pale and deep pink. So this wind flower and its many sisters represent the generosity of new friends, and my heart delights every time my eyes rest on what is now a delicate field of flowers.

JULIE RENOUF

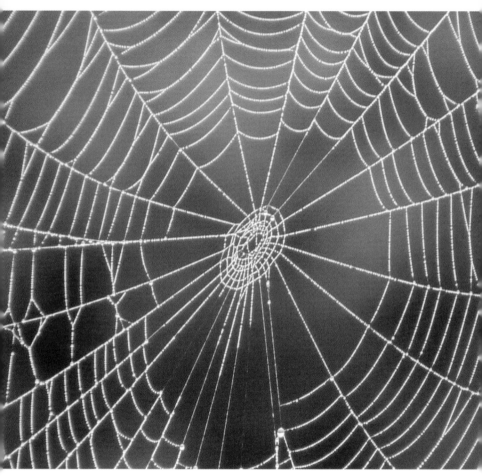

I'm grateful for unexpected surprises found in nature.

DAWN SWINGLE

A rug to warm the little toes.

HAILEY

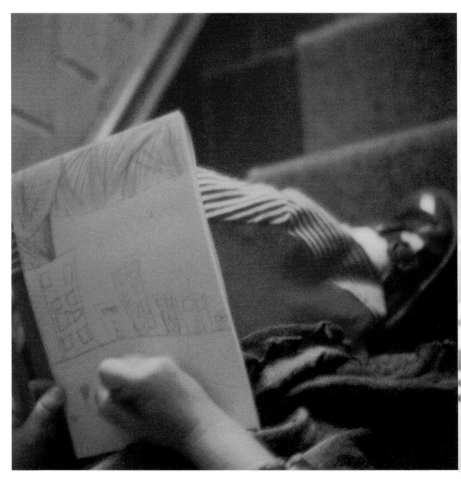

Just BE! Sitting on the steps watching P draw…
Her picture is called "City." Why does this make my heart swell?

HAILEY

I am grateful for each new day… and being lucky enough to spend some of my summer sleeping under the sky, waking up to the sun shining through the trees when we go camping!

MICHELLE CHRISTIAN

The stars in the sky.

PETA MAZEY

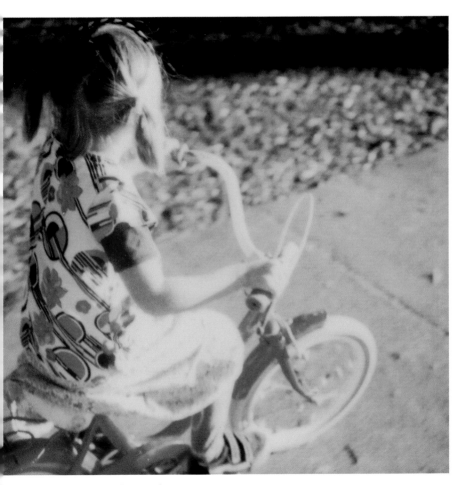

Every Tuesday I take her riding. Perfect moments.

HAILEY

So happy my girls have such a beautiful daddy.
He plays the ukulele to them as they fall asleep!

HAILEY

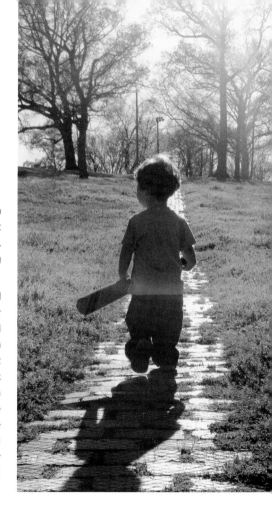

About three years ago my wife and I bought a house. It was in a neighborhood we liked, but we could only afford a house that had no yard. It was a bit of a drag having to walk the dog four times a day, rain or shine. But...

Shortly after closing on the house we learned that a beautiful baby boy was to join our family. The little spitfire is now two and I couldn't be more grateful for not having a yard. Other than not having to mow it, I get to spend most afternoons at the local park with our little guy. The picture (right) is him walking up a hill to the ball field where he plans to whack a few things. It is my favorite time of day. It's great not having a backyard where I could be tempted to just let him play without me... as I do something not as cool like laundry or dishes.

ALEX BARGE

"Next time a sunrise steals your breath or a meadow of flowers leaves you speechless, remain that way. Say nothing, and listen as heaven whispers, 'Do you like it? I did it just for you.'" —*Max Lucado*

LAURA SWANSON

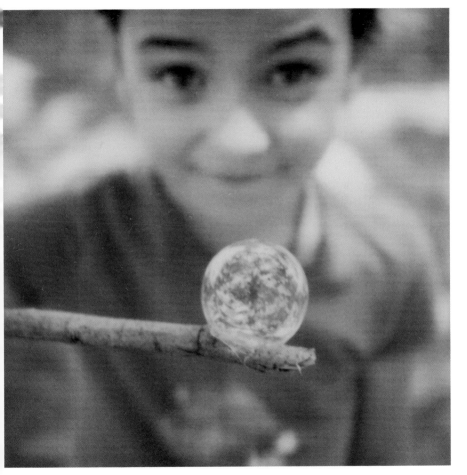

The park with friends, catching bubbles.

HAILEY

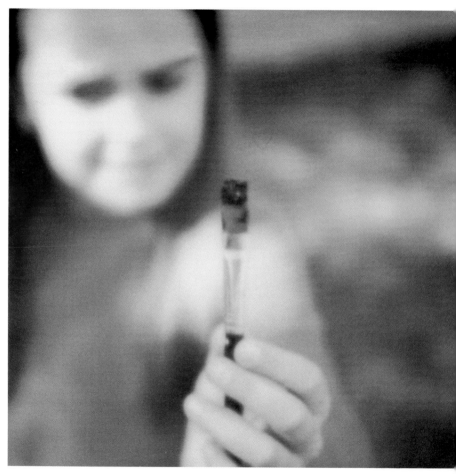

Working on a project together—a great age for fun!

HAILEY

My stepdaughter is one of the most beautiful people I know, inside and out. At first I was afraid that it would be too hard to be a stepparent, particularly one without my own children. But the truth is, there is sweetness and love with Katie. My relationship with her is helping me to become a better person. It stretches my ability to love unconditionally and with all of my heart.

LORI PORTKA

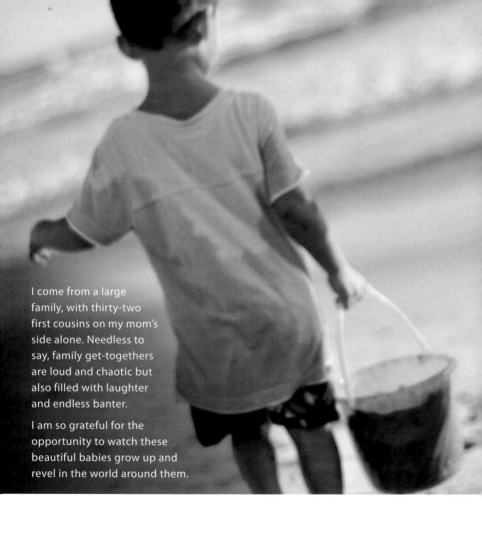

I come from a large family, with thirty-two first cousins on my mom's side alone. Needless to say, family get-togethers are loud and chaotic but also filled with laughter and endless banter.

I am so grateful for the opportunity to watch these beautiful babies grow up and revel in the world around them.

AYSHA TANYA

In my own bed… on my own pillow. Good to be
away but very good to be home with my girls.

HAILEY

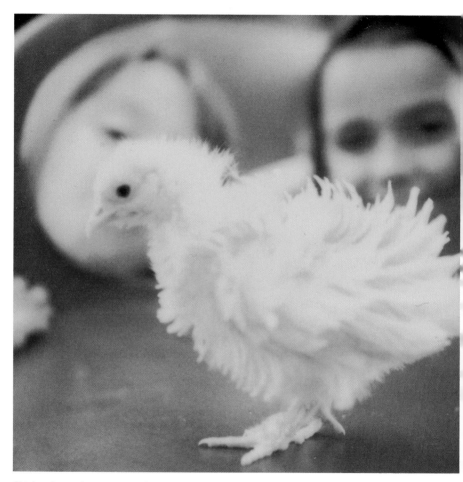

Chicken love—best pets ever!

HAILEY

I'm so grateful to have learned to recognize a significant gift. The case wasn't that I hated life, but I just never took the time to properly appreciate it, wonder about it, admire it. Acknowledge it. Recently, I watched the classic movie *It's a Wonderful Life*, where the main character finally realizes how well off his life is and that he, as an individual, cannot be replaced by another. That's when I realized that I, myself, am unique and irreplaceable. Each person brings a different aspect to the table, a divine purpose. And it would simply not do to just sleep and drift through this life until we meet at the world's end.

This moment in my life has been a sort of epiphany. I am more than grateful for LIFE, a gift that none of us asked for, but are unrelentingly given nonetheless. This includes the people and relationships that I have formed over the years, the irreplaceable bonds with my loved ones, the laughter, the joys and the tears, the journey of discovery, the experiences buried deep in my skin, the ephemeral dreams that my mind alone has seen, the everlasting beauty I am surrounded with… LIFE IS NOTHING BUT ENDLESS OPPORTUNITIES! I am incredibly blessed to have a loving family and supportive friends. So, so thankful for them and I fear to think of my state if I was deprived of their lovely communion.

BIRANI NYANAT

Lying among the daisies and buttercups, while the boys are at football training. It's actually warm, nearly hot. Wonderful.

XANTHE BERKELEY

Car trip with warm, glowing light… I love the
way I get space in my head on these trips.
HAILEY

The way she curls up on me and huggles in…
Makes herself at home on me.

HAILEY

I'm grateful for this wonderful gift of pregnancy. I'm surrounded by moms, pregnant to-be-moms, and grandmas in my profession, but I don't think I ever truly considered the beauty of life and growth until I was blessed with this pregnancy thirty-nine weeks ago. I think the first thing I did when I found out was call my mom to say thank you… During this journey of nine months, I've been thinking so deeply about life and relationships and love, and none of this would have even really been a blip on my radar had I not been given this gift of bearing a child of my own. Every kick reminds me of life, and, therefore, I'm grateful. Every pain reminds of the ups and downs of any long journey, and, therefore, I'm grateful. Every discomfort and nap and connection I experience reminds me of how soon it will be that we will meet our beloved, and, therefore, I'm grateful. I'm grateful for so many things in life but this journey of pregnancy has truly been something that I'll never forget, and something that I'll be eternally grateful for.

CHRISTINE POBKE

I am grateful for color! Without color the world would be a dreadfully boring place. Bright colors and sunshine can just make you feel better on a dreary, dark, cold day, or just if you're having a bad day. People would look boring if there were no color, clothes would look boring with no color, and I guess we wouldn't even be here without color!

I couldn't imagine living without color. You wouldn't be able to say, "Yellow's my favorite color!" or "I love the color of your top!" Color just makes you feel happier. The photo I took above makes me happy because of the colors in the cushion I am making. I don't think I would have liked my cushion very much if it had no color! Color is amazing!

EMILY WIND

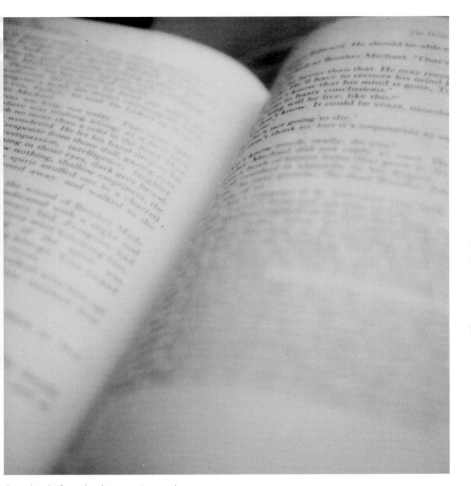

Great book. Completely engaging, and
made me think, smile, and cry, cry, cry!

HAILEY

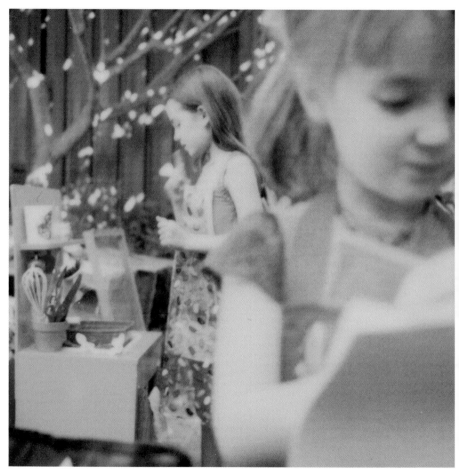

Visiting a little café in my own backyard.

HAILEY

I'm grateful for the gift of creativity… the opportunity to make art about my
life and to be able to share that wonderful process with others. I am blessed.

FIONA FITZPATRICK

My husband always forgets our anniversaries. The most romantic gift he ever gave me was a pink tweezer with a card saying "Happy birthday, now you can make yourself two eyebrows instead of one!"

That is why I was so surprised by the inscription on my dinner last night. I'm grateful for tomato sauce and "everyday romance!"

JANNE NORDVANG

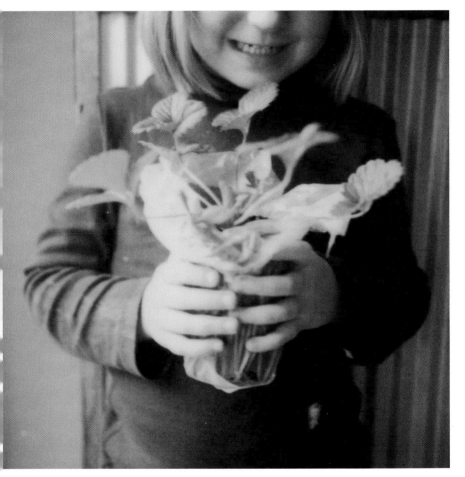

Strawberry plant to grow.

HAILEY

In my kitchen this amazing flower sits and smiles at me every day.

HAILEY

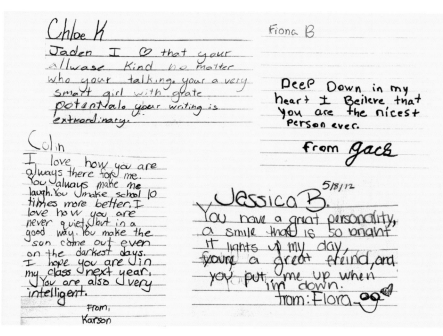

Chloe K

Jaden I ♡ that your allwase kind no matter who your talking your a very smart girl with grate potentale your writing is extrordinary.

Colin

I love how you are always there for me. You always make me laugh. You make school 10 times more better. I love how you are never quiet but in a good way. You make the sun come out even on the darkest days. I hope you are in my class next year. You are also very intelligent.

From,
Karson

Fiona B

Deep Down in my heart I Beileve that you are the nicest person ever.

from **gack**

Jessica B. 5/8/12

You have a great personality, a smile that is so briant it lights up my day, youre a great efreind, and you put me up when I'm down.
from: Flora

I recently did a "put-up" activity with my students. Each week we talk about ways to prevent bullying and what we could do if a bully picks on you or puts you down. Instead of talking about put-downs, we decided to talk about put-ups. I gave each child a note card and had them write their name on the card. I collected the cards, then randomly passed the cards out again. The students were then instructed to write one nice comment or compliment about the person whose name was on the card.

I collected the cards and read them aloud. The students were very excited to hear so many nice things about themselves. However, the real perfect moment of the lesson came to me the next day: A little boy said, "Remember when we talked about how good it made us feel to get compliments from our peers? Well, I think the better feel-good moment was when I wrote a compliment about my classmate."

Perfect moment!

JILL MARTIN

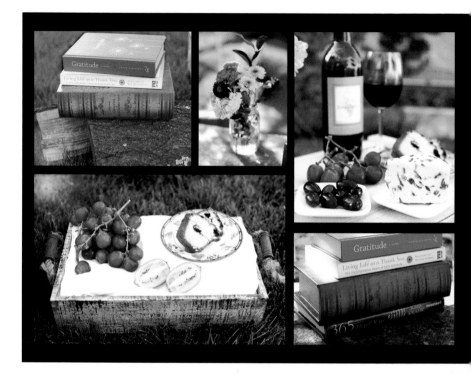

One of the things I am most grateful for is being able to taste.

Last November my dear aunt was diagnosed with kidney failure, and since then she has been going to dialysis.

It's a very hard thing to go through but she is so brave and positive and never, ever complains.

She has largely lost her sense of taste, so now I'm very, very grateful every time I eat and can taste something. I savor it, talk to my food, and thank God and the universe that I can taste!

But most of all I'm thankful with every breath for such an amazing aunt who has a faith that nobody can break and a heart that can love everyone!

GABY VILLARI

The late-afternoon cool change… I take the washing
off and suddenly feel more relaxed.

HAILEY

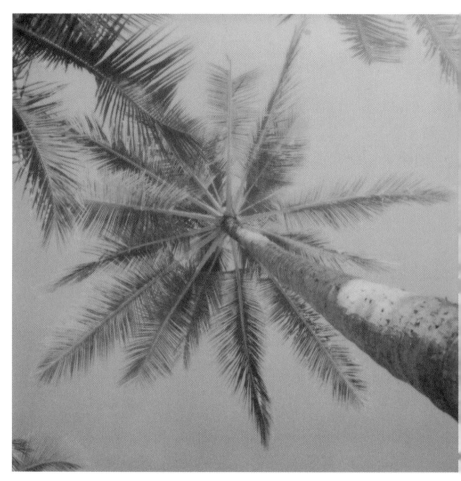

Four nights in Palm Cove... sitting in a pool under a palm tree.

HAILEY

My parents divorced when I was tiny and I would spend my weekends with my dad and grandparents. Every Easter my Gramma would pull out her Easter tree along with her little wooden Easter eggs. Ever since I can remember she had me decorate it just as I pleased. If I wanted all the eggs on the tree, then they would be on the tree, dragging it down with their combined weight. Time went on, as it does, and I grew up and moved away. Unlike some people who move to a different town, I moved from America to Scotland. That was four years ago. Since then, I have not been able to spend any holidays with my family. Last year, here in a tiny village in Scotland, I found what you see in my photo. They are little wooden Easter eggs. I was able to decorate my flat with them this year for the first time, and as I sat admiring them I found myself wondering why they were so significant to me. They represent some of the good parts of my childhood, the excitement and joy I had in anticipation of putting out the Easter tree. Those things are so easy to lose as you get older. So I am grateful, very grateful for little wooden Easter eggs.

KAREENA KAPITZKE

I took this photo during my first week in Jakarta in 1999. The woman was a beggar, crouched on the footpath of the local market. I was struck by her and the beauty that shone from her eyes, despite her obvious poverty. Her joy made my heart sing to the extent that I have hung her photo on my wall. I am always grateful for what she teaches me about joy, about aging, and about wisdom.

ISABELLA CHRISTINE ERSKINE-SMITH

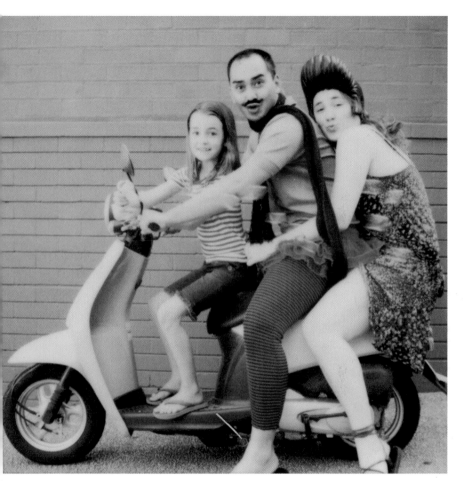

These three wonderful people who help
me with harebrained photo ideas.

HAILEY

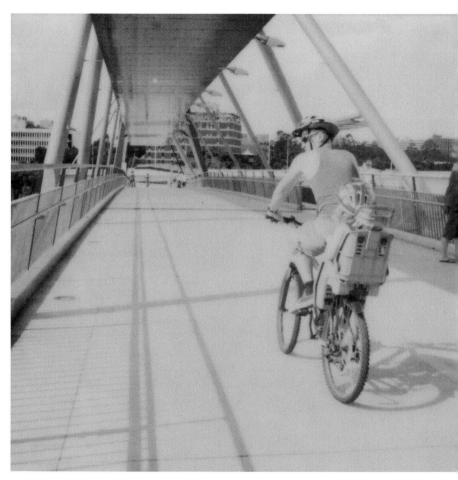

Rented bikes and had fun in the city!

HAILEY

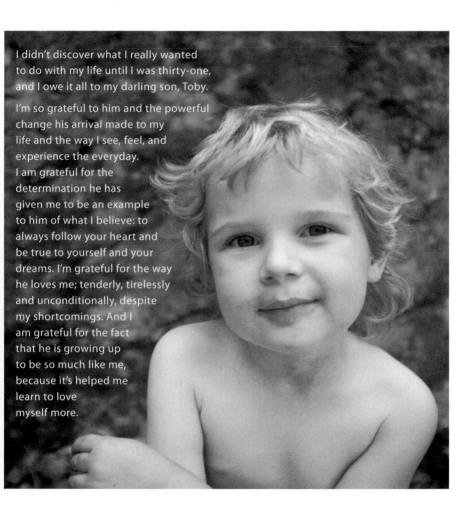

I didn't discover what I really wanted to do with my life until I was thirty-one, and I owe it all to my darling son, Toby.

I'm so grateful to him and the powerful change his arrival made to my life and the way I see, feel, and experience the everyday. I am grateful for the determination he has given me to be an example to him of what I believe: to always follow your heart and be true to yourself and your dreams. I'm grateful for the way he loves me; tenderly, tirelessly and unconditionally, despite my shortcomings. And I am grateful for the fact that he is growing up to be so much like me, because it's helped me learn to love myself more.

KATIE KOLENBERG

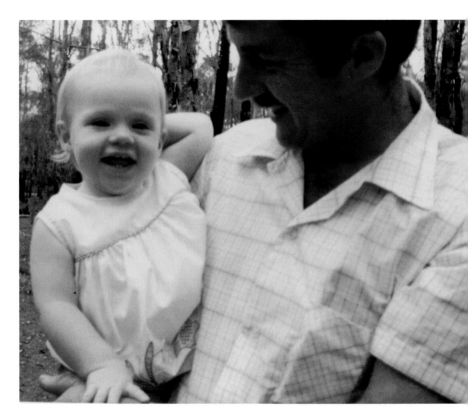

I am grateful for the memories I have of my father. Last year I lost my dad after a battle with leukemia, and every time I see this photo of him and me when I was a baby, it makes me smile. It's all those good memories that help through the harder times. He was such a kindhearted soul who always loved life. So many life lessons shared and learned.

KATHRYN WESTLEY

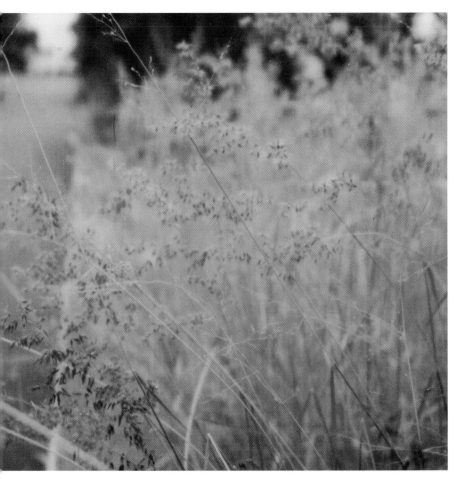

Every day as I drive up our street I see
this grass dancing in the wind.

HAILEY

My love, home, and working together.

Little projects that are fun to do and keep me in the now!

HAILEY

At the beginning of the year we moved to France from Australia, and I am so grateful to have this man by my side through this process. I would not have been able to do such a big thing like live in a foreign country where I am not fluent in the language without his support.

I am so grateful for his patience as I learn to communicate, for his love and support when I feel isolated, and for his joyfulness as we embark on new beginnings. This has been the hardest and most rewarding thing I have ever done, and I owe it all to my love, Morgan.

KIM TEILLET-MEUNIER

Grateful for family walks together.

DEB SCHWEDHELM

I am grateful to have been able to see such a wondrous sight as these beautiful elk walking down the beach in Oregon.

DEBORAH BUTLER

Being from Kentucky, where we do not see elk or beaches, it was an amazing sight—like something from a fairy tale.

Mosaics, good food, great company.

HAILEY

I'm grateful to my mom, who taught me to see things around me. Now I see
things that others don't even notice, while rushing through their lives…
KATYA RASSADINA

I'm grateful for having watched (and photographed) as my older sister tried to learn how to ride a bike. She's twenty-five and never learned how to balance herself on two wheels when she was little. She gets scared from time to time and can only ride for a few seconds at a time. But she's trying. And it's an incredible experience. It's never too late to learn something brand-new.

LAURA SCHAFER

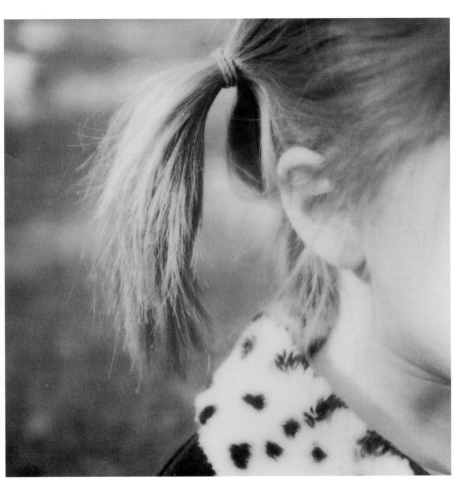

A little piggy tail that bounces!

HAILEY

Father's Day. Fun Ferris wheel. Going for a ride with a new lens to play with!

HAILEY

I am grateful for photography.

The way it captures moments that otherwise may not be captured!

The way you can put inspiration and photography together and come up with something amazing.

The way it can open your eyes and make you see the world in a different light.

The way it helps you remember life…

The way it tells stories.

The way you can look back and see what you were and what you have become.

The way you can show your life to someone who lives far away.

The way you can document someone's life… the little details and everything.

The way the shutter clicks—and the feeling you get when you think, that was a good one!

These things, these little details are what I am thankful for.

REBECCA JONES

Being hosted by the Owashi family while I was on a one-year exchange in Japan is one thing I am really grateful for. My host dad even asked Dad if he could have me as his daughter! Despite being a foreigner and stranger to the Owashis in the beginning, it was that gesture that made me realize how much I was loved. The Owashis told me everything there is to know about being a true Japanese: from the polite bows when greeting someone to harvesting crops in the fields! It was a year filled with new experiences and new memories. I got to view pretty cherry blossoms, make *onigiri* (rice balls), watch a baseball match, wear a kimono, participate in various traditional festivals, enjoy student life in a Japanese high school, use the Japanese-style baths every night, and so much more. I am so grateful for all the first-times that they have created for me and all the love I have received.

MIN TEO

Grateful to go places together.

KARTHIK NAGARAJAN & SARMISTA PANTHAM

The way she dresses makes me smile!

HAILEY

I am grateful for those rare chirpy bus drivers in public transportation. This morning I caught a bus, and my morning was instantly brightened by a warm smile and "A very good morning to you!"

Little gems like these are able to light a spark of happiness into any kind of day. Amusingly, this simple gesture surprised many of the passengers on the bus—who would normally swipe their GoCard and rush past. What a fantastic way to start the day! Thank you to that kind and awesome bus driver.

RENEE KING

Sunflowers. They never fail to make me smile.

SHANI DODD

Color, color, and more color!

HAILEY

My brand-new lens arrived after a week of waiting!

HAILEY

The first strawberry-picking trip of summer with my friend.

PETA MAZEY

I am grateful for my pet dog, Mowgli. He is a dog who takes "love all" seriously. He never tires of giving his love. I'm grateful that one lick or sniff from his wet nose to wake me up can make me feel so loved and worry-free.

SHEETAL THAKKER

Perfect toast… it's hard to make it just right. Avocado, lemon, salt, lemon pepper.
But when it's done well it is something you never want to end!

HAILEY

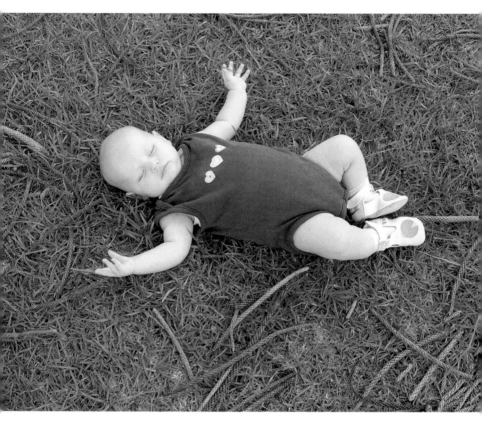

This was the first time my then nine-month-old granddaughter had lain on grass. She was immediately so calm and peaceful. Her little hands rubbed at the grass and her little legs crossed and uncrossed as she felt the earth beneath her. I watched with gratitude that she lives in a peaceful country surrounded by a loving family. She is now nearly three and continues to be curious and peaceful when outside and surrounded by nature.

JANELLE CHAPMAN

I'm grateful for cousin campouts, where lifelong friendships are formed.

NANCY ROBISON

I am most grateful for noticing glimpses of extraordinary things that reveal themselves from simple everyday moments. The photo illustrates just this for me. We were walking home from a lingering lunch along the shore. I was soaking up the sounds of the sea and the laughter of my husband and little boy, when I glanced down and noticed the hearts that seemingly lined our way home.

SUZANNE SPERL

Mosaic project.

HAILEY

This camera is sixty-seven years old and was given to my mom by a family friend. He was a photographer for the old UFA film company, which closed down after World War II. In 1945, he gave it to my mom so she could exchange it for a pair of shoes for me. However, she kept it, and so my interest in photography started at an early age. I´m truly grateful she didn´t exchange it for shoes! I was able to use it through all my school days in Australia, every year contributing to our school yearbook! It still works but film is hard to get.

LIANE WALTA

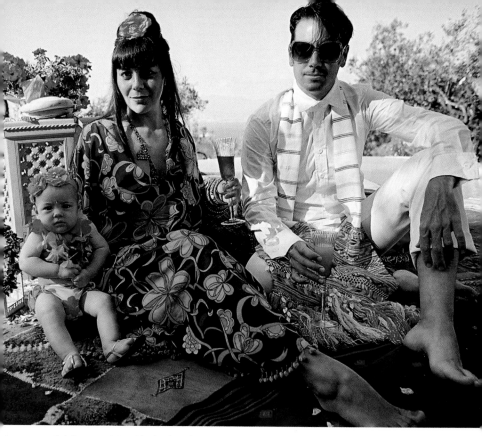

I am grateful for creativity. My husband and I are both very creative and are presented with wonderful opportunities because of this. It allows us to travel to exotic destinations, where we can work, show our daughter the world, meet interesting and inspiring people, and never take for granted even the smallest freedoms we have in the western world.

KASPIA

I am grateful for the two phone calls I received from James in the UK. I missed the first one as I was at work, but now I have a wonderful saved message on my phone that says:

"Hi, Mum, it's James. I love you."

The second call came and I was home and it was so good to hear his voice. Just awesome to talk to him like that. I miss him so much so this was just what I needed.

Thank you!

TERESA CASSIMATIS

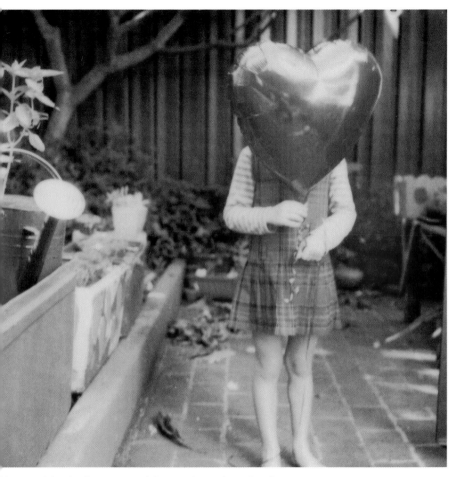

I love my job—buying props and then getting to keep them!

HAILEY

I am grateful for spring.

Now that the rainy season has ended and the warm spring weather has arrived, I am no longer cooped up inside our flat.

I can go for walks around the block with my owner and sniff intently at the exhausts of the cars parked around the flats and I can sit on the felled tree trunk in our backyard, watching the birds who are very busy at this time of year with nest-building.

Yours truly, Blackie the Cat

(Owned by Judith Rachmani)

JUDITH RACHMANI

love having a sleep-in morning... watching the light play
on the trees outside and dance on the walls of my bedroom.

JULIE RENOUF

I'm thankful for staff birthdays!

JO IN NJ

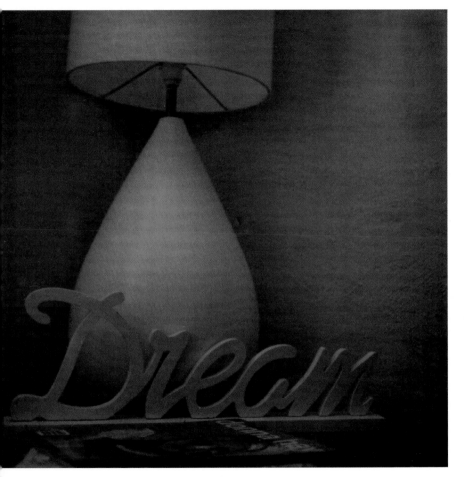

Photographed a birthday party and I'm never so happy to see my
bed. Sleep is something I am most grateful for today.

HAILEY

I am grateful for my niece, who is fearless, tough, bilingual, a perfectionist, and at four years old, she likes the same music I do. She's also sweet, caring, thoughtful, loves pink and princesses, but best of all, she wants to name her little sister Ginger... which drives my sister crazy!

MALLIKA PEREIRA

Wishing you all the love your heart can hold.

David and Mira's music touches my heart so deeply. Their music radiates love and devotion. I believe that when I create art with their music playing in the background, my work is infused with even more joy and openheartedness.

LORI PORTKA

I am grateful for long walks on the beach and discoveries like this!

MICHELLE CHRISTIAN

Zali started unschool today. Planted carrots—
fun—sun—love! Gardening makes me happy!
HAILEY

New garden ornament.

HAILEY

I love my shoes. They are (nearly) brand-new and I feel fabulous when I wear them. At the store I labored over the choice—a pair of lovely but practical shoes, and these, which I adored. I took the road less traveled, at least for me, and my heart lifts every time I see them—let alone put them on.

JULIE RENOUF

So grateful for them and all they are to us. To our family. For their love and guidance. Grateful for the example that they set—that love, perfect yet not so perfect, is what gets us through this life. Grateful for his laugh and for her never-ending encouragement. Grateful for every moment I get to spend with them. And so very grateful to call them family.

LEAH ZAWADZKI

Getting to work with people I love.

HAILEY

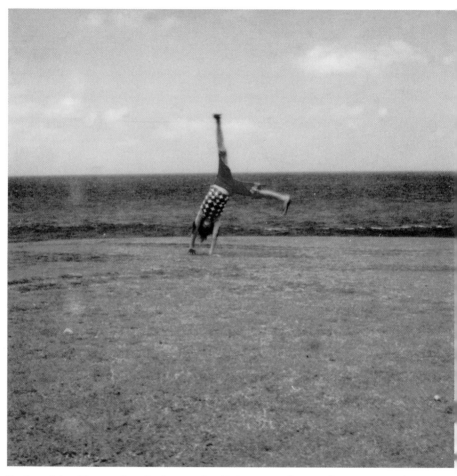

Hastings Point. Of everywhere I've been so far, this is my most favorite place! I am sure of something bigger and greater and more beautiful than I can imagine when I'm here.

HAILEY

I am grateful for dewdrops. If you go into the garden too late you miss them.

When I was a child I always thought dewdrops looked like diamonds. Now I am fifty, working in my garden, and I still think dewdrops look like diamonds.

When I took this photo I could not stop thinking of that song from *The Sound of Music*: "Raindrops on roses and whiskers on kittens"... These are a few of my favorite things (to be grateful for).

BELINDA WHITEHOUSE

I'm grateful for the heritage I have and that I get to know about it. The thought that I would not exist if it weren't for my great-great-grandparents Jasper and Lourilla makes me feel quite surreal. And a little frightened at the thought that, had they not known each other, that piece of the puzzle of ancestry would apply to another person. But it applies to me!

So I am grateful for my very existence.

JASMINE DODSON

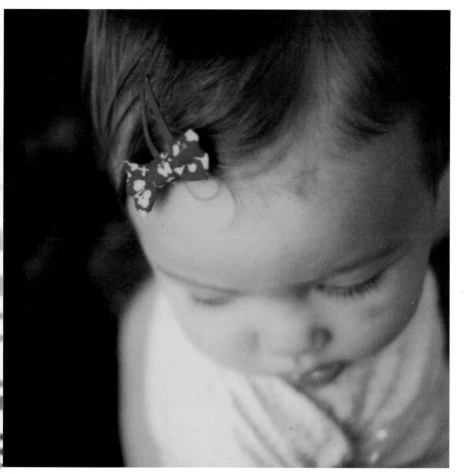

A little bow on a little head that made me
smile and coo when I was so very tired.

HAILEY

A pillow for my head. Worries fade in the dreamy world of a nap.

HAILEY

I am gratefull for my guinea pig Sleaky ♥

ALICE STONE

I'm grateful for the simple moments spent dreaming, looking up at the sky…
In these moments I feel like anything is possible!

ROWEENA TIMSON

A beautiful piece of music made for my new film.
So lucky to have so much talent around me.

HAILEY

My gorgeous sister is visiting. Grateful for friendship.

HAILEY

I'm grateful for food. And for how the world generously yields up its healing and wondrous goodness. For the amazing attributes of its colors, textures, and flavors. For how sourdough breads take on their distinct taste from the air in which they're born. For the way beans and rice form a complete protein when combined. For how chocolate and just about anything goes together. For how in lean times, a few cans of different beans, spread under the broiler and combined with oils and herbs and sun-dried tomatoes, can turn poverty into pleasure. Food has taught me so much and I'm grateful for everything it has to say.

PATRICK DODSON

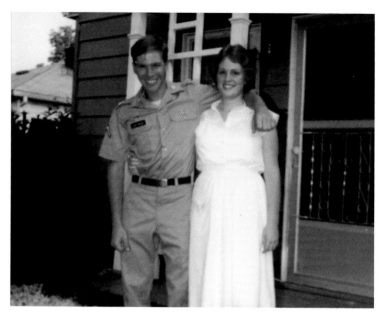

I am grateful for many things in my life. I have a home, awesome kids, a job I love. The only thing missing from my life was a life partner. I'd been divorced for over ten years when my teenage crush (Mark) walked back into my life. We met when we were fifteen and his family moved into our neighborhood. Mark and I developed a friendship immediately, one that has spanned thirty-five years. He went into the army, and I finished high school. When he came home on leave the summer after my high school graduation, we went on our first date! Unfortunately, our life paths went separate ways for many years until one day I looked him up on Facebook… not thinking I would even find him. But I did! He has since moved back to our hometown and we had our second date, and many more. He has brought love back into my life as well as my best friend. When we met again after so many years, it seemed as though it was just yesterday that we last saw each other… and we picked up right where we left off. I am grateful and thankful that Mark is back in my life, and this time forever!

This is Mark and me on our first date in 1980.

PATTI PARRISH

Practice, practice, practice. Grateful for finally getting it—skipping!

HAILEY

Morning light.

HAILEY

I am grateful beyond words for the people of the Dominican Republic. In fourteen short, enjoyable days they taught me how to be grateful for a life I at times take for granted. Despite the fact that they live in the worst conditions imaginable there always remains a beaming smile on their faces and joy in their eyes. They find gratitude in the simple things of life such as playing with marbles or an old bike tire. They taught me to be grateful for the hot shower I get to take every day and the lights I get to turn on when the sun goes down. They taught me to be grateful for the shoes I have on my feet and the roof I have over my head. They taught me to be grateful through the bad days and smile even when smiling doesn't feel right.

I would love to capture the warmth in their smiles and the joys in their eyes on film so THEY can have pictures of their families to cherish just as I cherish my wonderful photographs.

DEVIN WALFORD

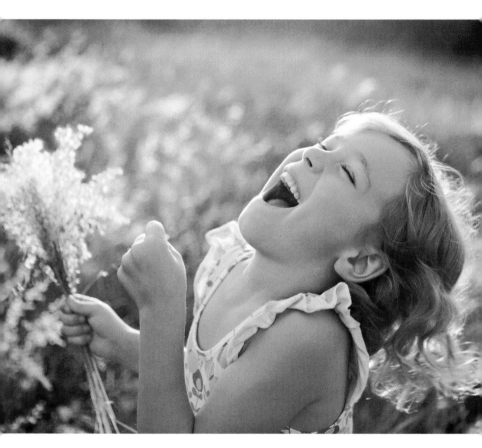

I am so grateful I get to be Audrey Lu's mumma! I love how everything is so exciting to her... how she greets every new experience with enthusiasm and gusto... how she spends her time here living in the moment! I love that when she feels joy she can't contain it... She will sing and dance and giggle and in those moments my. heart. is. happy!

ROWEENA TIMSON

A new little addition to my beloved garden!

HAILEY

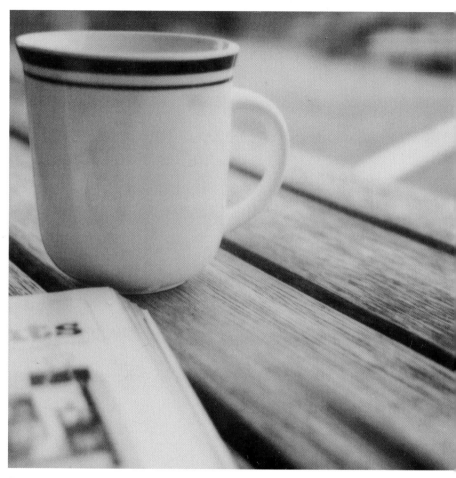

Quiet moment, special treat, a holiday, the sound of the sea...

HAILEY

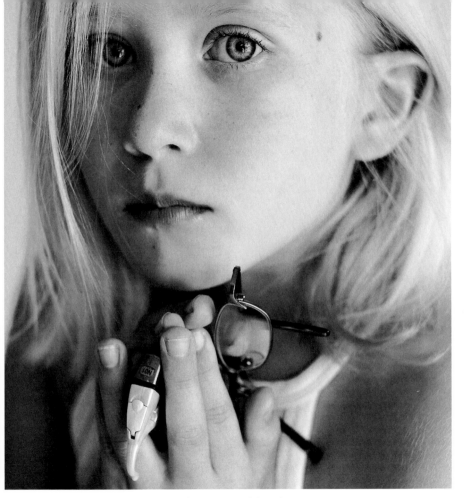

Grateful for technology and that my deaf daughter is able to hear.

DEB SCHWEDHELM

I am Grateful for...

ZALI BARTHOLOMEW

POPPY BARTHOLOMEW

Beautiful flowers drawn for me by my four-year-old. She gave me this drawing and said, "These flowers are for you, 'cause flowers always make us happy, eh, Mummy!" It just melts my heart.

CHRISTINE LOYE

An autumn leaf caught, a true celebration of
the season; its color and light—opportunity.

ODI WILSON

I took this photo in a Chinese Temple in Jakarta during Chinese New Year. The spiritual practice was palpable, and I am grateful for the breadth of awareness of the Divine across the globe, in a wide variety of spiritual practices.

ISABELLA CHRISTINE ERSKINE-SMITH

I can't stop finding so many things to love and delight in.
Collections by five-year-olds, and bare sandy feet.

HAILEY

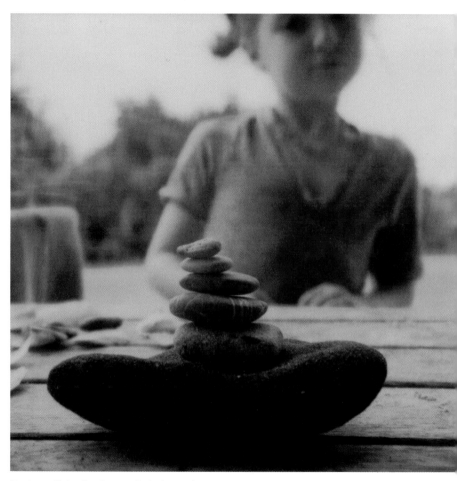

Her beautiful collections and playing and
beautiful designs all around me.

HAILEY

I'm grateful for her. She's the little girl I always wanted, full of personality and sassiness. She makes me laugh until I cry, and makes me feel as if my heart is walking around outside my body. I'm so grateful for having her in my life.

CHANTELLE ELLEM

I'm grateful for my artwork putting smiles on children's faces.

JODI WALKER

Grateful for this beautiful, inspiring, and overwhelming nature diversity called life!

ANA LÚCIA DA CRUZ

The light streaming into our house from the most beautiful sunset.

HAILEY

I am grateful for my family, for smiles and special moments, for hugs and kisses, and for the knowledge that there is nothing more important than love: unconditional, unrestrained, and boundless.

ULYANA PROTASSOW

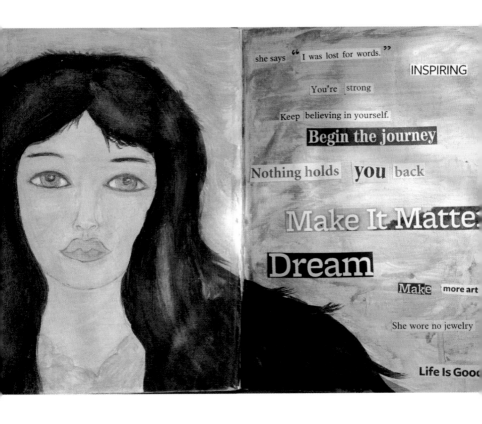

I am grateful to be alive. I am a cervical cancer survivor (thirteen and a half years) and I treasure EVERY minute of EVERY DAY!

DALE ANNE POTTER

When I was a kid, the safest place to be was in my grandmother's arms. She took care of everyone, and made us all feel loved! Now, the roles have changed. We take care of her now, but still, the nicest place to be is in her arms.

JANNE NORDVANG

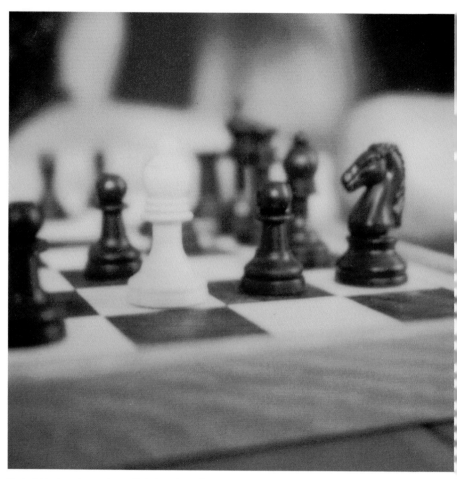

Grateful to be given a beautiful chessboard!

HAILEY

I'm grateful for the slowing down that happens on rainy days. Rain pounds on the tin roof, slides down ferns and sidings, seeps into the bleached earth. I sit and sip steamy tea and watch my daughter draw. I listen.

AMANDA NIEHAUS

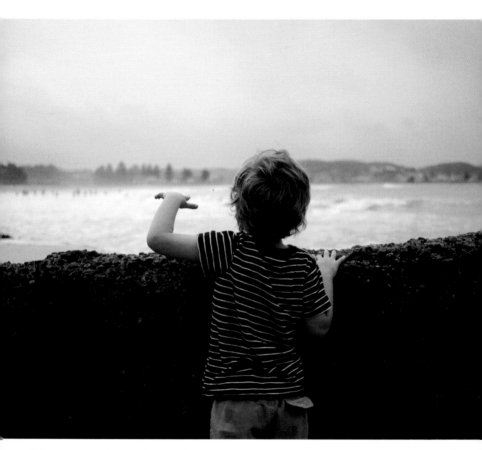

I document my days in photographs—a strange thing to do for a writer, I know. But when I follow in the steps of my four-year-old and stop to observe the minutiae, I realize that I am surrounded by beauty. The sense of calm that comes from gratitude is profound; I stop wanting and start appreciating. Contentment.

JODI WILSON

I had the opportunity to take this picture shortly after Drew
came home from Iraq. Today Drew became a daddy!

ALLISON LEACH

Purple—love this color!

HAILEY

"Grateful for everywhere I've been, everywhere I've yet to be, for the journey on the road less traveled while marching to the beat of a different drum…" —*Henry David Thoreau*

JANELLE GLICKMAN

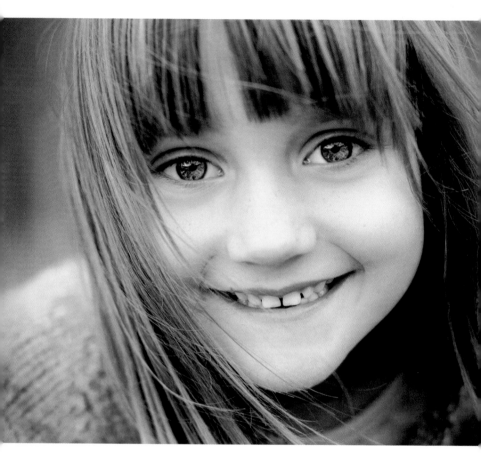

I'm so grateful and blessed to have my daughter, PerryFox, in my life. Having a child at the late(ish) age of thirty-five was like being let into a secret society. To share in life through the perspective of a child is a gift. I tell her every day, "I'm so glad you're my kid" and she tells me, "I love you until all the numbers are finished."

ANNA HANSEN

Grateful to Andrew for driving two hours to my parents' house. For Dad, who will work on my cameras when he's so busy, for Priya and her giggles and chubbiness, for Georgia and Errol, who made her, for Wii and Bene and dinner—yum!

HAILEY

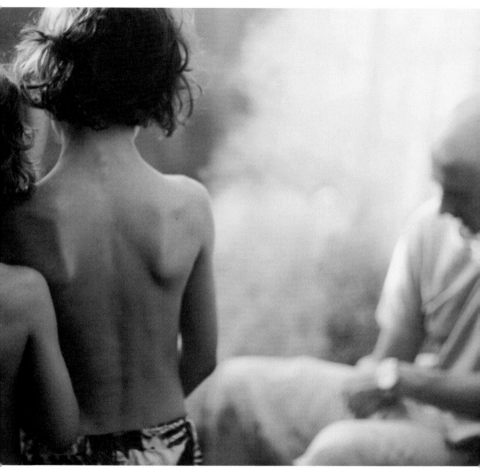

A glorious afternoon of sunshine, playing hooky from school, the start of the World Cup, BBQ, cakes, and peace and harmony from all my darling boys.

XANTHE BERKELEY

My son came home so excited yesterday, and for good reason! He has a dear friend that has never spoken outside his own home and hardly even to my son. Due to one of the disabilities that this boy has, most of their two-year friendship has been in silence. Well, they had just set up an IM on his friend's iPad and my son's brand-new iPod Touch. Almost immediately his friend was sending full sentences to him. They can finally have conversations! I am so grateful for this, it seems like a miracle to me. I'm so glad they have a way to talk and make their friendship even stronger. Now they are as thick as thieves!

NANCY ROBISON

I am grateful for the little piece of sunshine that arrives in our backyard, around 3 p.m. It is soft and warm on a winter's day. I make time to stop, enjoy a coffee, and bathe in the sun like a lizard.

CINDY CAVANAGH

The other day, my daughter stood in the light and talked to me about her day. I grabbed the camera, a bunch of flowers, and captured this moment.

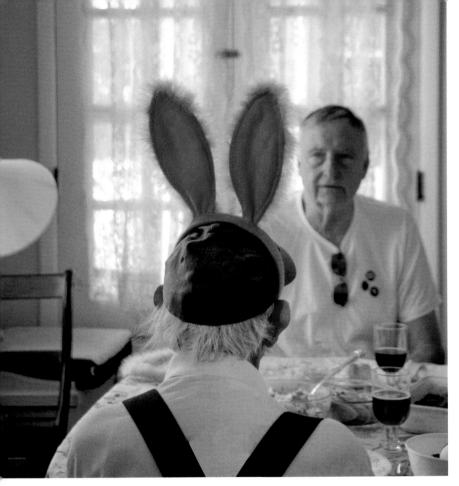

I am grateful to be able to spend time with my parents (in their eighties) and my husband and thankful that they are as silly as I am! I bought bunny ears for all this Easter. Here's my dad (in the ears) having a serious talk with my husband.

JANET L. VARAN

My wife made fish for dinner today. I hid in the car when she wanted me to come in and eat. I'm grateful she did not find me and that my dinner got cold. Grateful I had a good reason for making hamburgers instead!

RONNY

So grateful for holidays to near and far places! Road trips or overseas adventures…
Seeing and experiencing new things is super exciting!

ROWEENA TIMSON

Here's a little grandchild that I thought would be a real hardship for her mother, who is young and has had a hard life. She's been an exceptional pleasure and has a wonderful mother. For this, I am grateful.

DAWN YAGER

Exercise at Mum's.

HAILEY

I'm greatfull for my mum.

JOTHAM SHEPHERD

My husband, Erik, is the love of my life. This winter, at age thirty-seven, Erik found out he was adopted. It was overwhelming, confounding, and sad all at once. The day after he found out we decided to take a walk at the local science center. We were looking for some peace. I am grateful for signs. When I looked over at Erik sitting with our daughter this beautiful burst of sunlight came through and radiated over him. I knew things were going to be okay. I knew there was hope. That I am truly grateful for. Hope.

HEATHER ANDERSEN

I've been a fan of the band Lifehouse since they started. I wanted to go to their 2012 concert in Manila but I couldn't afford to. I entered five promo contests to win a ticket and at the last minute found out I had won!

It was an amazing concert and so much better than the first time they had their concert here in Manila. It was a sold-out concert! And of course the moment that I've been waiting for (for almost four years too!), their finale song. "Everything"! Oh GOD! If only someone could record my happy face at that time! As the band started to sing the song

"Everything" I started to cry again; this song made an impact on my life in so many ways, and it is also the reason why I had the time of my life that night and was able to share it with my friend. It was really an amazing experience and unforgettable concert. I am so grateful for the free concert ticket, so grateful for the joy and the happiness, so grateful for the company who chose me as their winner, so grateful for my friends, for I know they prayed hard for me to win the contest, and so grateful to God who has always blessed me.

GENIEVE CELADA

Visit from a dear friend… loads of chatting!

HAILEY

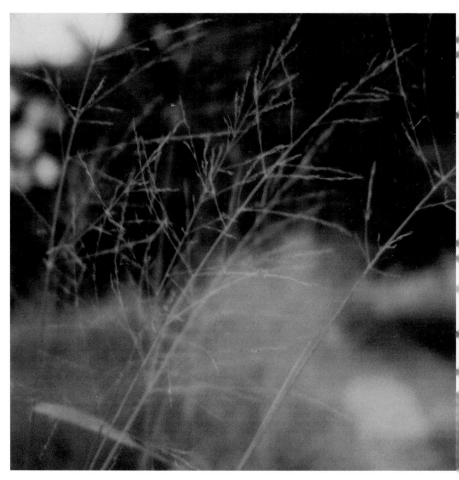

Long, long grass. Afternoon light.

HAILEY

I heart summer... beach adventures, the warmth of the sun on my skin.
Icy-cold gelato, the smell of flowers in the air. I'm grateful for these days!

ROWEENA TIMSON

My grateful list goes on and on. I've kept it simple. I bought these black tights at Woolies the other day and the very next day we had the cold snap. They are super comfy and warm, I can wear a dress and I don't have to shave my legs. What more could a girl ask for?

JANINE COVENEY

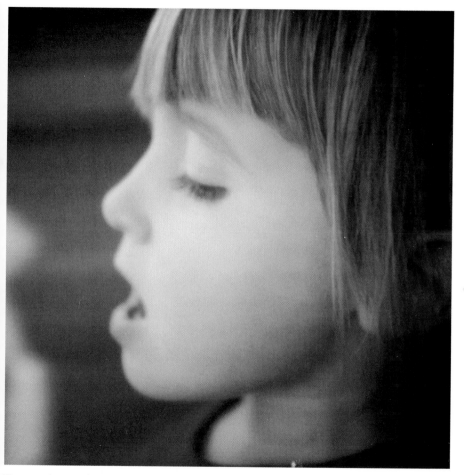

The way she sings her heart out to Angus and Julia Stone!

HAILEY

X2 SX-70 and X2 spectra! I am super-duper grateful to Val and Peter.

HAILEY

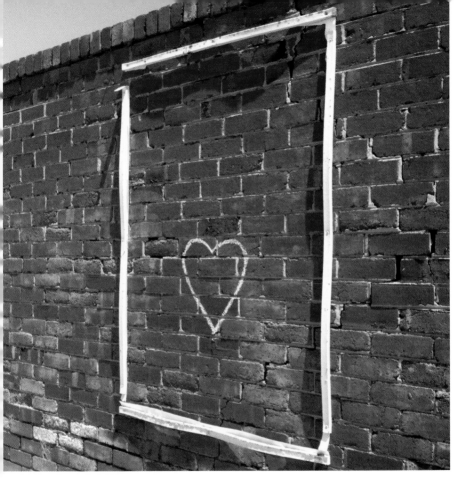

I am grateful for random acts of inspirational graffiti. This love heart was done in chalk, and the next day it rained, so I was glad I got to see this before it was washed away. A lesson in the impermanence of all things I guess.

JULES GALLOWAY

On a recent vacation to Arizona, I became reacquainted with beauty in one of the most visually stunning places I have ever been.

This geological marvel includes majestic red sandstone walls artistically sculpted by centuries of wind and water erosion. These natural phenomena are glorious in their presence, glowing with deep yellows, oranges, reds, and purples as the sun peers within.

The experience was both arresting and moving at the same time. It was as if time ceased, and the outside world stood quiet and at attention. All of my thoughts and anxieties evaporated, and I was left standing in the sand, with my eyes and mouth wide open. For the short period of time that I visited the Upper Antelope Canyons, I heard silence. The static had stopped.

I believe that the world needs more beauty; as an artist, I yearn to experience it, create it, and express it. And though oftentimes these experiences are fleeting and all too infrequent, I am grateful for what they bring me. Beauty forces me to pause, to behold, and to feel insignificant. It leaves me fulfilled and inspired, yet craving more. It reminds me of everything that is right in the world; that static is transient and that silence is a beautiful sound.

JEFF SOLAK

I am grateful to have had the opportunity to visit the Avenue of the Redwoods in California and to spend that time with this man... the love of my life, my soul mate, my friend, my husband for the past thirty-seven years. Amazing vacation, amazing life.

DEBORAH BUTLER

Breakfast at lunch!

A tree passed daily but
only seen today.

HAILEY

I'm so eternally grateful for the love of my children and for a recent trip to Paris (we piggybacked on a daddy work trip). It's a dream of mine to travel and to help my children understand the world and all the color and cultures of the people that live in it. I took this photo on our first day in Paris, totally unscripted, and the joy in this image will uplift me forever. The joy they had and I had seeing the city through their innocent eyes. If we could only be a little more childlike—open to equality, full of curiosity, and amazed by nature and its simplicity.

JODY RYAN

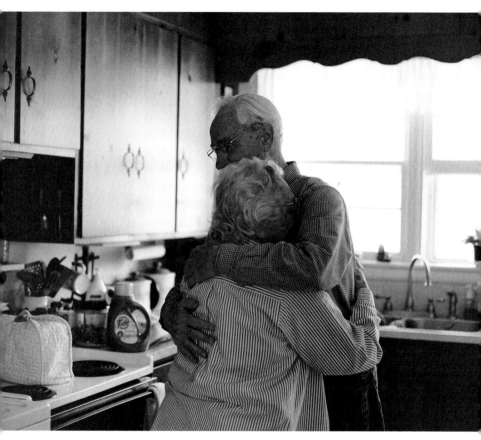

I'm grateful for two people who have lived a life of love and friendship. A solid example of lasting happiness and companionship. My husband and I took photos of them one afternoon. Our most treasured moment was witnessing a simple, daily routine: a hug in the kitchen after reading their devotion and singing a hymn. I will forever be grateful for that.

KATIE SCHMID

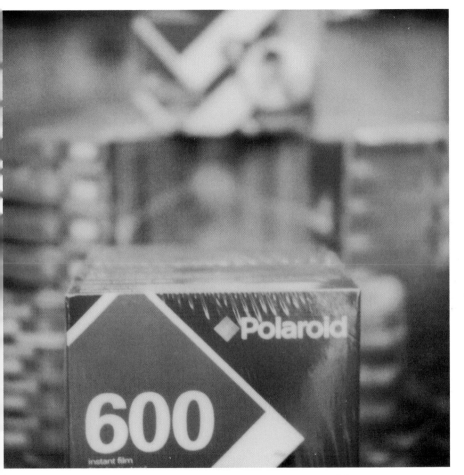

Arrived today from the United States! Enough to finish the year... so grateful
that I have a darling husband who is happy to spend a near fortune on Polaroid!

HAILEY

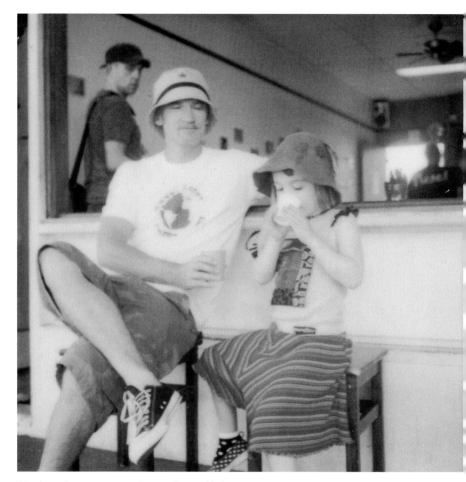

Watching these two enjoy their coffee and babyccino!

HAILEY

I am grateful every day that I have children who love to explore new places and see the world just as much as I do—we are always planning our next adventure and they approach travels with the most incredible enthusiasm and open-mindedness.

KIRSTY LARMOUR

I have a lot of reasons to be thankful for my brother. He put his life on hold to help me through a hard time this winter. In 2010, I experienced stroke symptoms on my left side and hours later was diagnosed with a brain hemorrhage at age thirty-four. Doctors reassured me that it was likely a one-time event and to move on with my life.

Early February, as I sat down to dinner, my left arm went numb and hot and I knew I was having another bleed. Anxiety set in. Big time. I was not coping well. Trying to take care of a three- and five-year-old with no room to move, I was stuck in my own sadness at the thought of not being there for my husband and kids, dealing with continual negative thoughts and fears about my own mortality.

I called my brother and asked him to come stay with us and try to get through it together. Luckily, he had some freedom with work to stay with us

for a month. As soon as he arrived, I knew things would be okay.

Our family enjoyed his company. He was there for me. He held me up. He talked with me. He checked in on me daily to make sure I was improving. He wanted me to succeed so he stayed an extra two weeks. Lots of memories and milestones were experienced and shared. I am forever grateful that he came. This photo is a snapshot during the time of our six weeks. It was taken by my five-year-old son. This was our setup while he was here because of our daily meditation. We would sit facing each other, eyes closed.

I am grateful for the picture as a reminder of this time. It's not a fancy picture but it is real and holds a lot of positive emotion for me. This is where I started to heal.

MARLA CHRISTIE

Grateful for laughter.

DEB SCHWEDHELM

Grateful to have each other, even if we're lost.

KARTHIK NAGARAJAN & SARMISTA PANTHAM

I was lucky enough to take this photo of a box fish while I was snorkeling on the Mid North Coast of New South Wales, Australia.

HAYLEY JONES

I'm grateful for my love of snorkeling—it gives me a chance to escape and to experience a whole other world under the water.

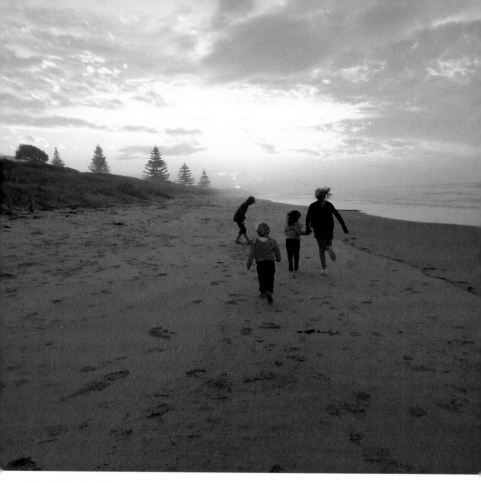

Grateful today for time spent romping on the beach with my four awesome kids. I love the way that even on a cold windy afternoon the time we spend on the beach somehow always brings peace and calmness to our busy life. We live in paradise.

CHRISTINE LOYE

This little toothless grin I love. Two big teeth nearly through!

HAILEY

You listen with

your whole hear

My husband and I see a therapist as a gift to love and honor to each other. This hour with Bridgette has become a sacred time for us. We hear each other in therapy. We listen. Bridgette holds our stories in the light. She helps me see both of us with compassionate eyes.

LORI PORTKA

I am grateful for nature in all forms. I wake up to this hydrangea bush in full bloom in the summer, and marvel at its latest resident. It's easy to be grateful when you are in nature.

HEATHER ANDERSEN

ASRESHEIE
BIIIO. ♥♥♥♥

I UPRESEAT YO
MUM

There is nothing more satisfying as a mother than
being appreciated. For this I am grateful.

JESSICA MARSHALL

Sitting inside the tuk-tuk in the pouring rain in Phnom Penh, I marvel at the way people in that city take life in their stride, despite many obstacles—monsoon rain being one of them. I am grateful for the experiences that show me the depth, beauty, and resilience of the human spirit.

ISABELLA CHRISTINE ERSKINE-SMITH

My three sisters and I had discovered the resting place of our aunt—our mother's sister—who passed away at three months of age in the early 1930s. My Nanna only spoke of her daughter's death toward the end of her life. She was ninety when she herself passed away. To have held the "secret" so close must have been heartbreaking. My sisters and I held a private memorial for Velma Kay to honor her, her mother, and our mother. The photo shows clouds passing slowly over after our words were spoken. I call it "Angel over Ollera" and find comfort and gratitude in the image and what it conveys. My Nanna was a very generous and loving person—a legacy we are all so grateful for.

JANELLE CHAPMAN

Hanging around with two lovely girls and
lots of yummy food and chats.

HAILEY

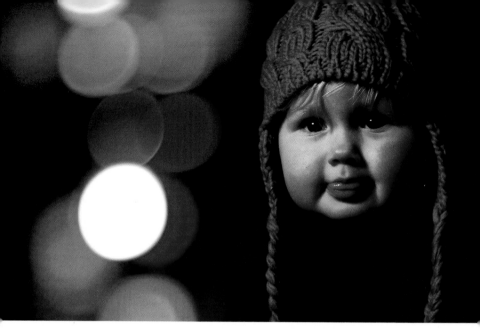

It's kind of a cliché, but what I'm most grateful for is our daughter.

My wife and I did not want a baby for a long time because we wanted our "freedom" and to see the world and travel.

After a couple of years of traveling we were in India (2010) and met an elderly couple. They were traveling most of their lives and saw lots of the world.

We talked a bit (mostly about traveling) and then I asked them about their children. But they had none. And then it struck us—we thought

it was kind of strange not to have any children, a unique person created by us. Maybe it was coincidence that we met this couple at that time in our lives or maybe it was meant to be…

At that moment we decided to try to have a baby, and our daughter was born on November 1, 2010.

We named our daughter Leela Catharina: Leela because she was conceived in India and Leela is a name from India.

We are very grateful and blessed to have such a wonderful daughter.

NICO VAN DER VORM

I'm grateful for treasure hunts in Grandma's basement.

JANNE NORDVANG

My daughter Poet is pure joy. Looking through the lens I am reminded of my blessings and drawn into the present moment; the here and the now. Her first top knot—absolutely top notch.

JODI WILSON

I'm grateful to see my brother enjoy seven minutes to himself after spending the last three years dedicating every waking moment to providing for his family. He had to gut and rebuild his home from the ground up after learning it was encased in toxic mold. He did this all on his own with help from friends at church, all while working full-time and helping his wife care for their three children, one of which has special needs. At thirty-four, he was recently diagnosed with wet macular degeneration.

If one person can overcome life's obstacles, it is my brother. I'm grateful to have captured Josh enjoying a few moments of fishing alone before he helped the kids try to catch a few.

RACHEL TAYLOR

I am eternally grateful for my family, my future husband, Andrew, and our two rescue dogs Charlie (left) and Max (right). It's hard to believe these two pups were abandoned at the pound.

As a child, I never had a dog or a puppy, so at twenty-four years of age, it was time. It was worth the wait. We found Max first, at about twelve weeks old.

He was a scrawny little thing with a bad case of kennel cough. No one knew what breed he was going to turn out to be so no one wanted him, but how could we say no? It was the best thing we ever did. He turned out to be an independent but sweet-natured pup.

NICOLE GARDEM

Then a year later we came across Charlie. He was a little insecure but once he opened up, he was full of boisterous personality. Both have love to give in bucket loads. They are a match made in heaven, bestest brothers, our ying and yang puppies. The memories we have had the last two years have been priceless. Just to see their happy, smiling faces at the end of each working day is enough.

If I could save more dogs I would. Adopting these two angels has inspired me to photograph shelter dogs to raise awareness of how many still need homes. One day I would love to start up my own rescue farm where unwanted animals can have a safe, secure, and loving home.

They only see each other once a year, for a few weeks every summer.
But it's like they spend every day together. Cousins are the best.

XANTHE BERKELEY

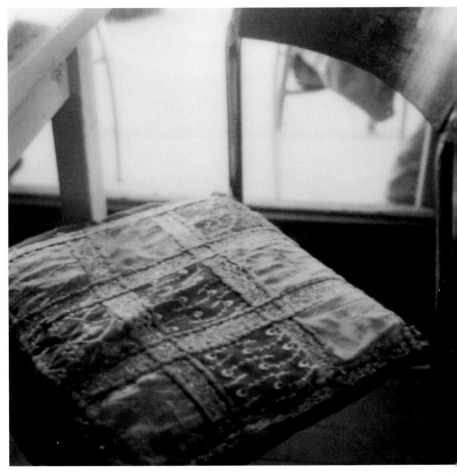

Cafés… I love to go to them. I love Sundays…

HAILEY

After a disappointing day I was leaning against a wall looking at the photos I had taken, hoping there would be a decent one, when I noticed this little ladybug sitting on the wall.

This little suprise made up for an entire day that felt otherwise wasted! So I am grateful for all of life's little surprises!

MIKE CAMPBELL

Today I am grateful for this precious wee stone the girls found out in the garden. What a find! We'll be adding this to our box of family treasures.

CHRISTINE LOYE

I am grateful for a brilliant, generous, and creative partner who
provokes, inspires, and insists on room for all things human.

IMAGE BY LILLY BLUE, WORDS BY JO POLLITT

I am grateful for the colors of fall and the crispness in the air!

MICHELLE CHRISTIAN

I am so grateful to be able to easily and frequently escape the stresses of city life because we have such an amazing landscape on our doorstep— this beautiful, calm place is just a half hour drive outside Abu Dhabi, the capital of the United Arab Emirates, where we live.

KIRSTY LARMOUR

It's the simple things in life that count. I am grateful for the Melbourne sun. I am counting down the days until spring comes and drops the little freckles across my nose, and turns my skin a golden brown. There's nowhere I would rather be this summer than lying on a sandy Melbourne beach.

ROBYN MORRISON

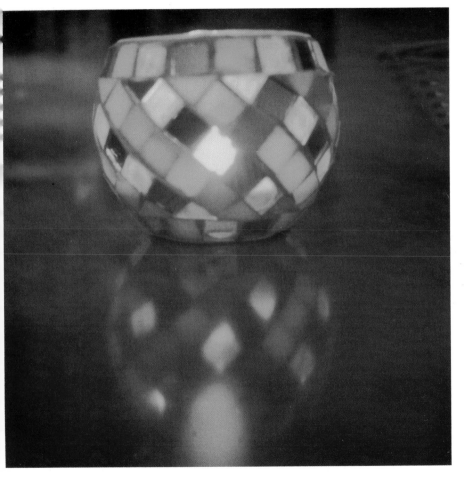

Indian food for dinner. Spontaneous decision to go out and enjoy!

HAILEY

I'm so grateful for the years my son got to spend with his grandpa! Grandpa was seventy-two when my son was born, and lived to see his only grandchild attend his alma mater. I was very blessed in the in-law department!

JO IN NJ

I am hugely grateful for our beautiful golden retriever,
Alaska (his hair a brilliant white). He has such character
that I forget he's a dog sometimes.

ROSS EYRE

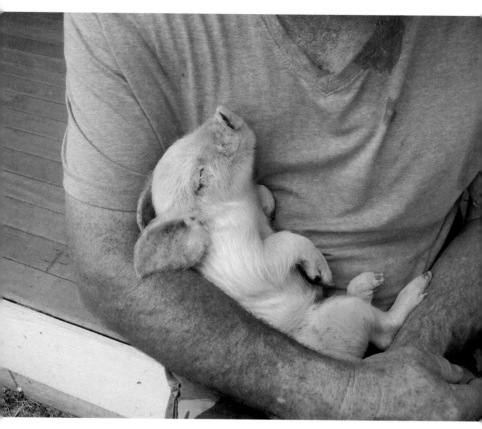

This is our pet pig Gimpy. Gimpy was rolled on by his mother when he was only a few days old, and looked to be crippled for life. Our family brought him up to our house and raised him. This picture was taken just after he had his first real meal in a few days, and the look on his little piglet face always brings a smile to mine. I am truly grateful to have him; he brought me weeks of joy and still entertains me with his unique personality.

SAMANTHA WATERSON

Finally got my nose pierced! Fifteen years wanting
to! Grateful not as painful as I thought.

HAILEY

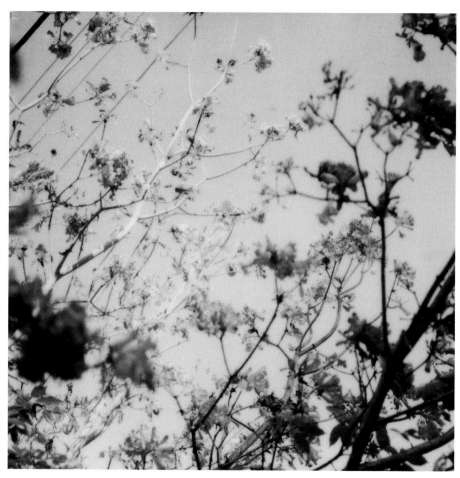

Pink on blue with warm light.

HAILEY

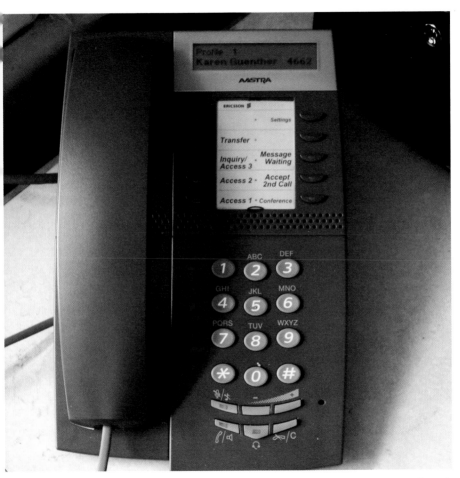

I am grateful for the new phone in my office. The old one had sticky keys, and now I don't

have to worry about calls not going through because the buttons didn't connect.

KAREN GUENTHER

I'm grateful to know love.

The kind of love that makes you think your children playing about in the bath is the most beautiful thing you've seen.

A symphony of droplets and splashing.

A dervish twirl of life in black-and-white turned Technicolor.

My love is their birthright.

Theirs is my rainbow.

TAMARA CRISP

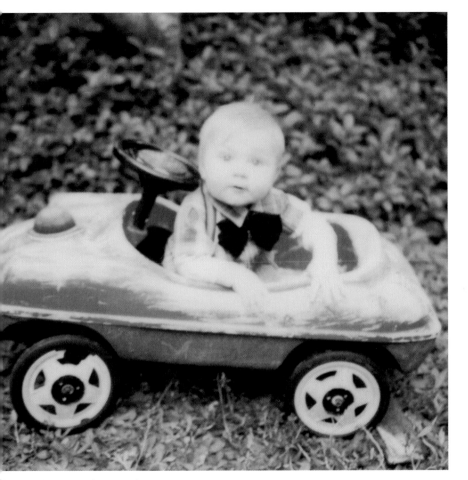

Playing dress-up with my nephew.

HAILEY

I'm grateful for the creativity and humor that people put into everyday objects. While traveling on a country road I spotted this unique Tin Man mailbox, valiantly standing watch over his daily post. Very creative and it brings a smile to the face.

NANCY ROBISON

Our home has endured 10,482 earthquakes and three unprecedented snowstorms in the last two winters and counting.

I am so grateful that every day our home is still standing and that my family is safe.

SHAR DIVINE

I'm grateful that after thirty hours of labor, my son, Roo, came into this world.

Roo is almost two weeks old. He is more than I could have ever imagined. I hold him and struggle to imagine him being in Kesh's belly, even though I know he was. He made me a father. I'm his dad. He's my son. I love him.

I tell him that I'm going to be the best dad for him. I want to help him become a great person—someone who brings so much goodness into this world.

I love Kesh. She is everything to me. When I'm not with her, I want to be. My life is better because of her.

TIM COULSON

Long day… his arms make me so happy.

HAILEY

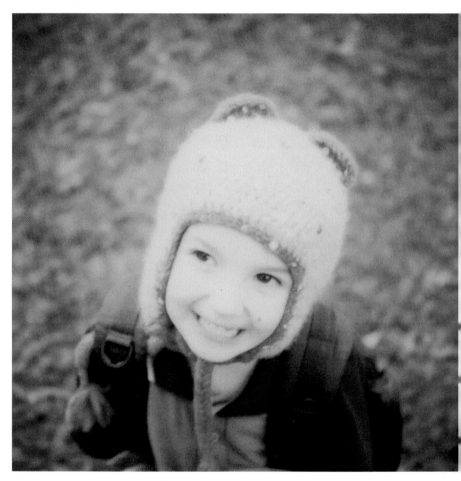

Five years today! I am so grateful for you…
lighting up our lives so very much.

HAILEY

I am so grateful I have two hands that helped build a home for a needy family in Mexico. We did not use a single power tool, only pure man power. I am so lucky to have a home with electricity and running water. This family had the bare necessities and we built what I would call basic shelter, but they now call a home.

How fortunate I am to be able to do this for them, and leave them with a new roof that doesn't leak and a door that locks. This experience of building a home for this family with my church made me more aware of what I have to be grateful for in this world.

TINA CASE

I am grateful for the VSA Alabama (Very Special Artists) program that partners local artists with emerging artists who have disabilities or chronic illnesses. Being able to photograph this was a blessing for me.

VIRGINIA JONES

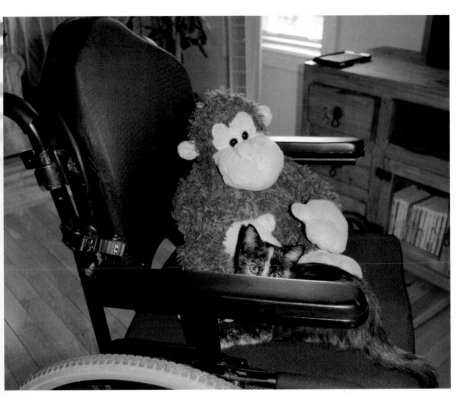

Every morning I wake up and think about my plan for the day. As I get ready to embrace the world, whether at home or in the community, I have to wonder what mobility aid will I use today. Not too long ago, but long enough, I was in a head-on collision between my car and a dump truck. Even though it doesn't need to be said, I'm obviously very lucky to be alive—and even more so to have all my limbs. This morning when I woke up I focused my gratitude on not only the wonders of modern medicine, but on the advances and availability of mobility aids. I am so thankful and grateful for wheelchairs (electric and manual), walkers, crutches, and canes.

SHANNON YOUNG

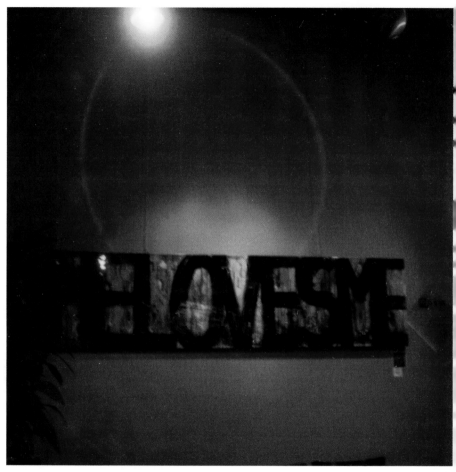

Surprise coffee and cake alone with my love. Yummiest cake
and beautiful art saying "HELOVESME"… and I love him.

HAILEY

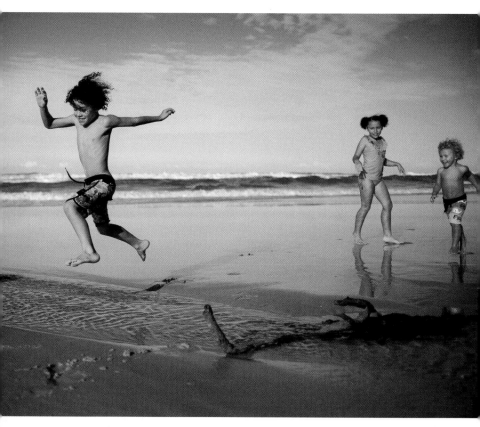

I am lucky to live close enough to the ocean that my family and I regularly get to sink our feet into the sand and hear the sound of the waves. My grandfather bought land at the Gold Coast many years ago when there was not much happening there. The land remains in my family and we stay there as often as possible. Watching my children play on the same beach both my father and I have played on all our lives fills my heart with a deep sense of happiness and gratitude.

RACHAEL NIXON

I am grateful for the FUN I have every day with my children (ages one and four). I am grateful that my husband and I have found a way—made a way—for me to stay home with our children while they are so young. I can read books all day, find the messiest projects to tackle, and make the funniest lunches around. I am grateful every moment of every day. This is the best time of my life.

HONI

Cartwheels in the sun. Beautiful warm days together.

HAILEY

Fun day out—kids festival!

HAILEY

These are my grandmother's cup and saucer sets. I love using them with friends—their vibrancy, design, and history enrich the new memory-making experience of connecting with special people. For my Nana and her heritage, I am grateful.

ISABELLA CHRISTINE ERSKINE-SMITH

I'm so grateful I live a mile away from the Detroit Zoo. I have to go often to catch the polar bear swimming over the tunnel!

CANDICE WHITFIELD

These lovely Bengali women taught me the meaning of gratefulness. They told me of the progress they'd made since becoming literate and about their savings-and-loan program—each contributing fifty cents a week over months and years. Eager to show me the results, they grasped my arm in a swirl of saris and smiles and took me on a tour of their new homes, rebuilt after the floods. Walking through those bamboo, mud-floor huts, swept and tidied meticulously—shy children peeping round curtain petitions—I will never forget the utter joy on their faces and their sweet sense of accomplishment.

ZELL SINDEL

Handmade felted vest... finished! Ready for my "ready-to-pop" niece.

HAILEY

When I see my reflection looking back at me through the beautiful dark eyes of my son, I am reminded of the greatest hardship of my life and I am filled with gratitude. The way his eyes are shaped, the curve of his lashes and the way they lay perfectly on his cheeks did not come from any gene I have. And yet somehow they are mine all the same. It turns out that the disappointment of only seeing one line on the pregnancy stick month after endless month can be the most beautiful thing you've ever seen when you are holding your three-day-old baby who would've never been in your arms if the stick had read positive. It's true that I may not ever know what it feels like to have those first minutes when my baby is ushered into the world all to myself. To have the first feel of his skin on mine or soothe his first cry. I wasn't the first to breathe in the scent of my sons and it wasn't my heartbeat they heard when they laid their sweet heads down. And the first whisper of the words "I love you" into

their tiny perfect ears were not mine. All of those moments are deservedly reserved for the first person to ever love them. And for that moment, of witnessing my babies coming into the world, I will always feel a little bit envious. But another type of mama needed that moment all to herself. And if I had to do it all over again I wouldn't change it. I would, every time, let her keep those first moments of my child's life to herself in return for what she has given me for the rest of mine. I am so very grateful for these amazing women who made me a mother. I can honestly say that I am grateful for the hard road of infertility I have traveled down. The same road that helped me realize that sometimes what you think is the worst thing imaginable can actually end up being the best thing that has ever happened to you. And the best thing that ever happened to me is this love right here. This heartthrobbing, soul-satisfying, hurts-so-good kind of love I have for my children.

KORTNI MILLER

Grateful for laughter.

DEB SCHWEDHELM

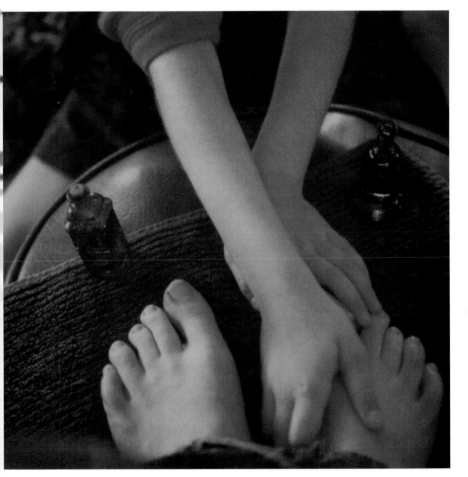

She loves to play massage shop.

HAILEY

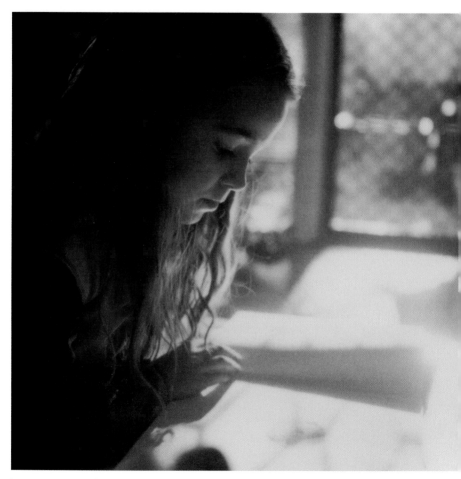

Love our morning light. Streams into our lounge every day.

HAILEY

I am grateful for a little girl's bravery and never being afraid of standing out in the crowd. Mia was three years old when we found out she was deaf. As someone who spent my whole life trying to "fit in," I'm really grateful to her for showing me that it is much more fun to be daring and different.

AMANDA LONSDALE

Capturing the gratitude of a brand-new, long-awaited PUPPY! And little boys! What's that poem? "What are little BOYS made of? Snips and Snails and PUPPY Dog tails? That's what little boys are made of!" Oh, how my heart leaps with gratitude for little boys and puppy dog tails!

ANDREA DOAN

I love my twenty-five-year-old UGG boots—they keep my forever cold feet warm, summer or winter. They are a bit worn out, and about ten years ago my son said, "Mum, the war is over!" I'm so thankful that they last so long and it's a bit of "home" (Australia) for me.

LIANE WALTA

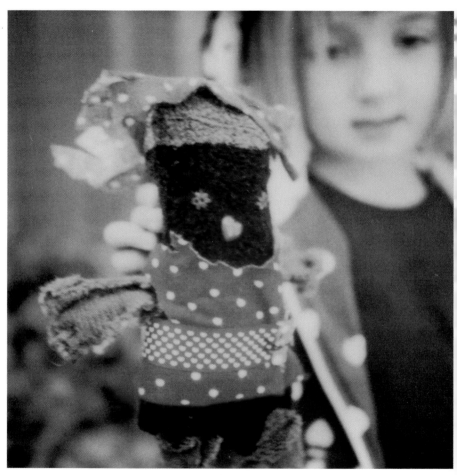

Littlest is sick, so my darling Z made this for her last night. So cute, so sweet, and I am thrilled with joy at the love they share.

HAILEY

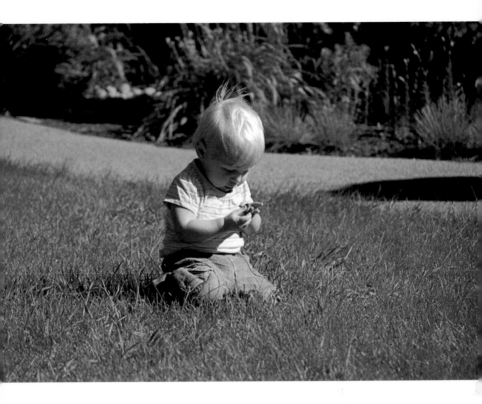

I am grateful. I am thankful for the little things, for each new thing. I love how my girls bring to my eyes the attention deserving of the "un-lovely." When my Bean picks up a single stone that is of no great color or value and has a look of such wonder, I am in awe. I am reminded that there is something in everything to be thankful for. When my Kimmers swings for what seems to be hours on end, I am reminded of the simple pleasures of the breeze through my hair and the uplifted feeling of flying, if only for a moment. My heart is full of grateful.

ANGIE KROEKER

I knew the little one would love Tiger, our new kitten. What I didn't realize was how much love my eldest would give her. It turns out she's the perfect TV-watching companion at the end of a busy day in the sunshine.

XANTHE BERKELEY

My little big girl is home and they are back in the thick of playing.

HAILEY

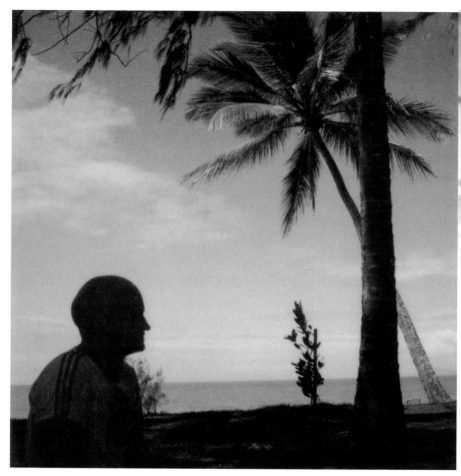

Can't hardly believe how lucky I am to do a job I
LOVE and be flown to beautiful places to do it!

HAILEY

This is my mom and my daughter. I'm grateful for my mom. Becoming a new mother myself has opened my eyes to the overwhelmingly pure love a mother feels for her child. I never fully appreciated her until now and I totally get it!

CANDICE WHITFIELD

I am grateful for this man. The father of my children. Who pushes his son up hills. Across bridges. Over snow. Through mud. In the sun. In the rain. So he can experience the nature he loves so much. A man who sheds secret tears.

Frustrated at being unable to "fix" a little body that won't work like it should. A man whose sadness turns to joy when that little hand holds his—when those eyes say the words the mouth cannot. I am grateful for their love.

ELIZABETH ROE

Spring and my favorite tree is budding new leaves.

HAILEY

Just had to smile when I opened my lunch box
at work today. Grateful for "everyday romance."

JANNE NORDVANG

I am so grateful that I found myself in India earlier this year: the color, shapes, and sounds of such an ancient culture, plus the kindness and curiosity of the locals, has made for an explosion of creativity still impacting even now, and a renewed softness and kindness in my heart for others as I am even more grateful and appreciative for the opportunities I have in life.

FIONA GARRETT-BENSON

No one told me just how hard being a parent would be, and it is hard, but I have laughed and felt joy every day since my daughter was born for that I am truly grateful.

FRANK KELLY

Shadows and warm light.

HAILEY

Thrift store bargain—$5 fills a bag!

HAILEY

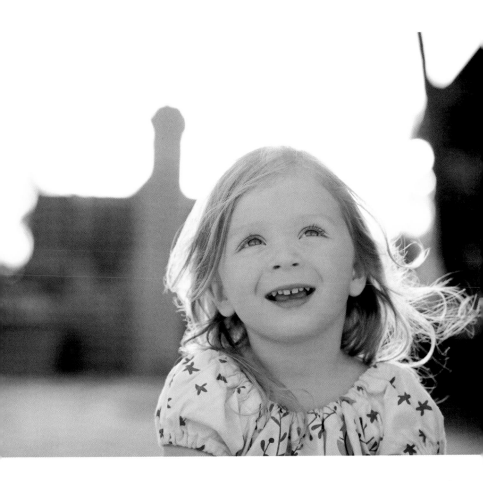

I am grateful for perfect moments—with my beautiful daughter and greatest love, in an amazing place I'm so blessed to be able to travel to, laughing together and feeling free.

MELANIE RIDDELL

Thank you for being someone I can trust.

It is hard to explain the intuitive feeling of trust I felt immediately upon meeting Tony, the owner of the Masello's Garage. He is warm and kind and goes out of his way to give good mechanical advice. He helps me make the right decision when it comes to my car. I trust everyone who works there completely, and they have been taking care of our cars ever since.

LORI PORTKA

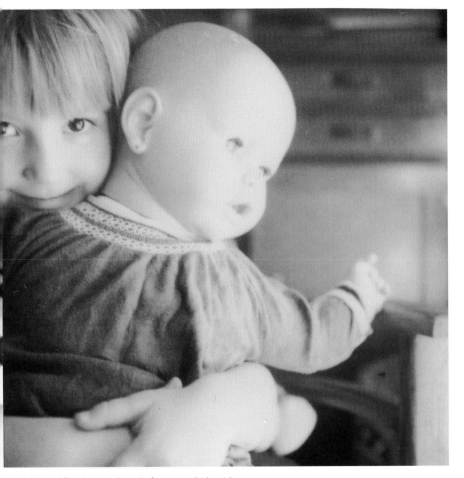

An old friend fixed up and ready for a new little girl.

HAILEY

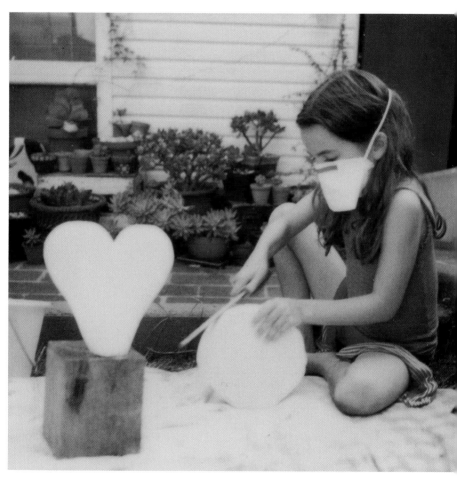

New project with my buddy.

HAILEY

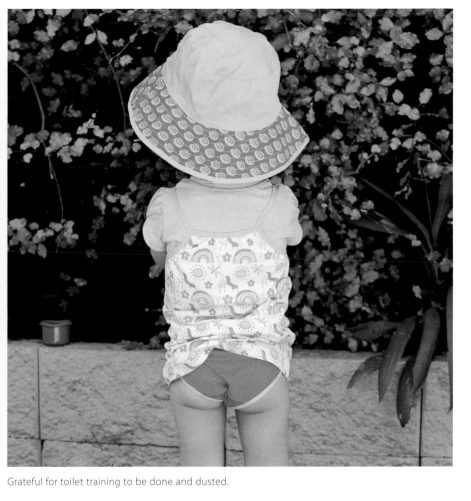

Grateful for toilet training to be done and dusted.

NIKI SPREKOS

Grateful that despite having severe food allergies he
is otherwise healthy, happy, and enjoying life.

MARSHA BRADLEY

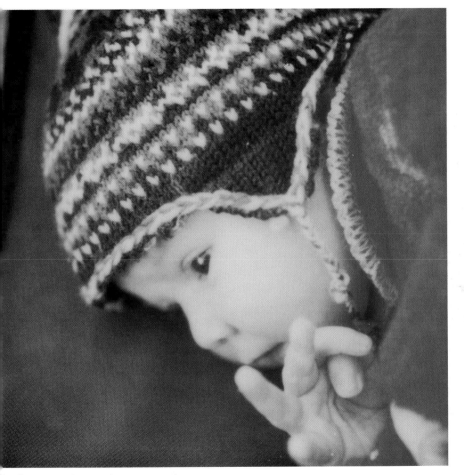

Really enjoying having this one around…
Her smell! Oh, so delicious!

HAILEY

I love red!

HAILEY

I am grateful for my dad (Jim) who has taught me that you never need to grow up. He tries to make someone smile every day. He will often appear in a funny wig with just his T-shirt and underpants on and walks out saying, "Well, I'm ready to go!" When my mum was having chemotherapy, he would wander through Canberra Hospital wearing all sorts of funny wigs, just to give Mum and others a smile. He may be biologically in his seventies, but his mind is just like a seven-year-old. I am so grateful for the example he shows me of how to live and how to have fun.

LIZ ARCUS

I'm grateful for a daughter who is full of wonder for the natural world and who will happily let a praying mantis walk all over her.

TAHNIA TRUSLER

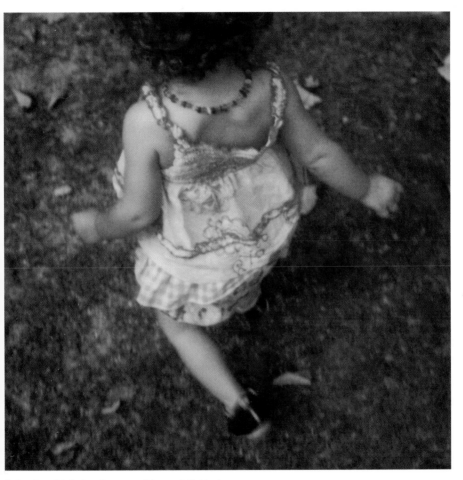

Following this little miss around. I was delighted
to watch her wonder at the world.

HAILEY

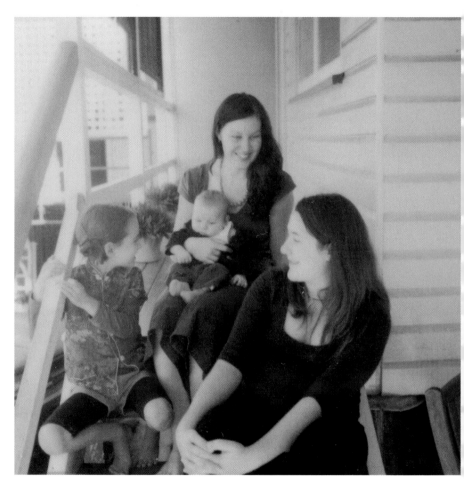

What I always wanted… friends and sisters
having kids and enjoying them together.

HAILEY

On March 15, 2012, an EF3 tornado hit our village of Dexter, Michigan. It was a very rare occurrence and took us all by surprise. We are all so grateful for many things. Miraculously not one person even needed medical attention! But that is not the entirety of the story. Our beautiful community came together like no other; helping each other, holding each other, loving and caring for each other. This terrible storm brought many of us who simply passed each other in the streets every day together. Suddenly we knew one another's names. We searched for missing cats together. We shared meals, tears, and hugs. We went from just living in the same neighborhood to being a "neighborhood family."

It has been more than three months since the storm hit and we are beginning our summer events in our small village. Many of us have still not returned to our homes. But we meet up for dinner, music in the park, or chat in the street as we pass, watching the progress of our home repairs.

As much as the tornado really hit us hard, it has given us more to be thankful for than what we can ever grieve over. Personally, I am most grateful for meeting my neighbors I had not yet met, and becoming even closer to the ones I know. I wouldn't change a thing. Honestly! The tornado was a gift, wrapped in a disguise of high winds and devastation.

KATHERINE PFIEFFER

I'm grateful for my bride.

DRAGOS LUDUSAN

I'm grateful for marrying this joyful, amazing
man and getting to live each day by his side.

LAURA LUDUSAN

Thrift shops and precious finds...
Eight little spoons and forks.

HAILEY

I'm grateful for my yoga practice. It keeps me grounded, reminds me to stay present, and teaches me to approach life with an open and compassionate heart.

LARAH KENNEDY

Rows of basil freshly planted…
I have a gardening bug!

Time alone with my big little girl.
Making patterns on a loopy-loop.

HAILEY

'luff is a big cat.
he has a big basket.

ick will bring the basket
for Fluff.

ere is a li le it
is Flu s it n.

T littl ki e ca
d pl

Remember when you were young and it seemed so hard? Something we forget because we do it every day. However, I am really grateful I was taught to read. Plus I am grateful I found this old schoolbook to remind me of that wonderful feeling you got when you sounded out the word and got it right for the first time.

BELINDA WHITEHOUSE

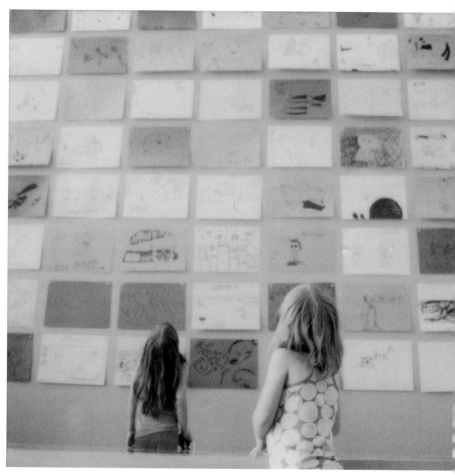

Gallery at Southbank. So lucky to share amazing days with
my kids and have so many interesting places to visit.

HAILEY

Grateful for humor.

DEB SCHWEDHELM

I am grateful for beautiful artwork from my six-year-old son, full of color and love and joy.

The reason he drew this for me was because earlier that morning we spotted a rainbow that began/ended in our street—and agreed that if you see something so magical it definitely means you can skip school for that day! He was so grateful for being allowed to skip school.

LOUISE TEE

Peace, alone, and it feels wonderful.

HAILEY

Friends have been far away for six weeks but now home again.

HAILEY

I am so very grateful to live and raise my family in a town that is home to many different cultures that enrich our lives daily.

LIZ ARCUS

This image was taken in Shepparton, Victoria, Australia, during refugee week. The map was there for people to pin on it where they came from.

I feel so grateful for the places I was able to grow up in. I started my childhood in the Northern Territory of Australia, and finished in the Great Southern region of Western Australia.

To be able to call the rugged, rich, and encapsulating coast my backyard as a child has helped me to appreciate the beauty of our wonderful country as an adult.

SARAH KATE DORMAN

My sunflower seedlings are recovering from the chickens sitting on them. I am so glad—I wasn't sure they would make it!

HAILEY

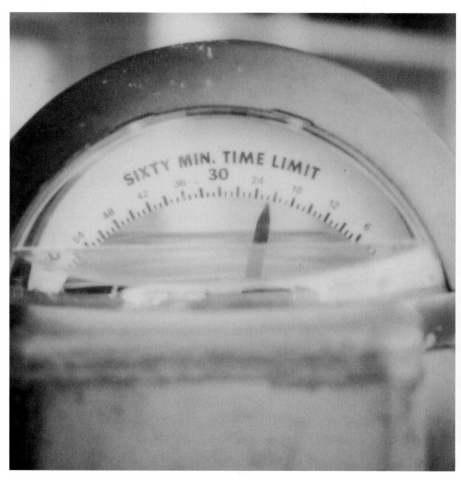

Nothing better than money in the parking meter
when you have no change!

HAILEY

Thank you, beautiful carrot family, who burrowed into the ground and danced in the wind and found your way all the way to New York.

And I am grateful to meet you for I too was lucky enough to find my way to New York from across the Atlantic...

MICHEÁL ROWSOME

I am grateful for my three beautiful sisters. Each
one of us is like a mixture of the other three, so
none can exist without the others.

BROOKE HOLM

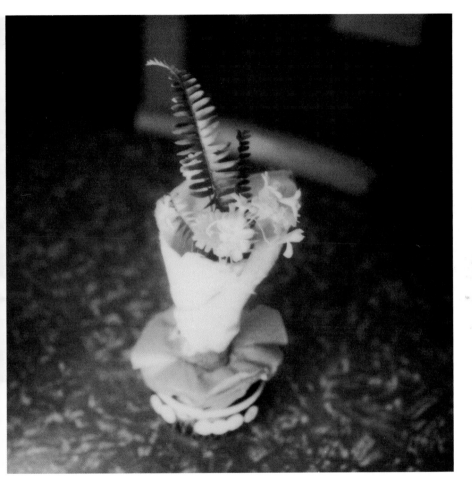

Handmade for me. The little card reads "I love Mum."

HAILEY

Bad day… but sitting down among some amazing, tiny, and beautiful pieces of nature helps bring me some perspective.

HAILEY

I am so very grateful for the fact that I have learned how to be grateful! Who knew you had to actually NOTICE what's going on around you to truly be a part of this world?

For such a long time I was so stuck in my image of what I had convinced myself was the perfect life, I failed to look up and smell the flowers (and the manure)!

JENI MATTHEWS

Going through a hugely bitter divorce has enabled me to make choices that have changed my life in incredible ways: a new house, a new village, a new job, new friends, and a new perspective on life that allows me to see the greatness in even the most horrible things (like a divorce). Even better, I am starting to see how these changes are positively affecting my three-year-old son as well!

I am so grateful for the love and laughter I share with my furry baby each day! While my husband and I wait with hope and anticipation for our own baby, Nala reminds us that love is found in so many places.

SARAH KATE DORMAN

Mum and Dad and me in 1960—the year I was born. I feel so grateful whenever I look at this special photo. I have always felt LOVED by my parents and my family. I believe that loving and being loved is one of the most universal feelings, yet I know that so many people do not always feel loved. This photo portrays my parents' love for me. I wish love for all people.

JANELLE CHAPMAN

For Valentine's Day I got a thrift shop crawl!

HAILEY

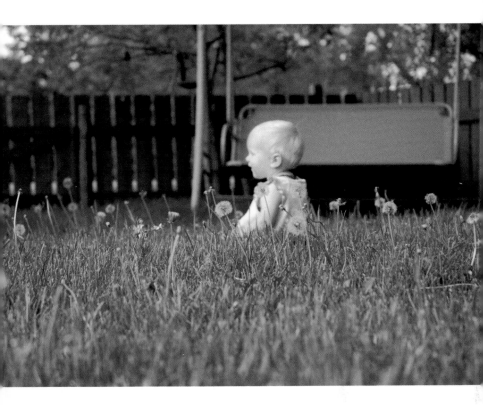

Out in the yard with the dandelions. I find it odd that this "weed" is actually something beautiful. I am thankful for the simple things that surround our everyday lives and bring just a splash of "something" to the table.

ANGIE KROEKER

I am grateful for those unscripted moments of sweetness between my children. Unprompted, my son grabbed his sister's hand and guided her down a trail in the Kansas prairie.

WENDY RICE

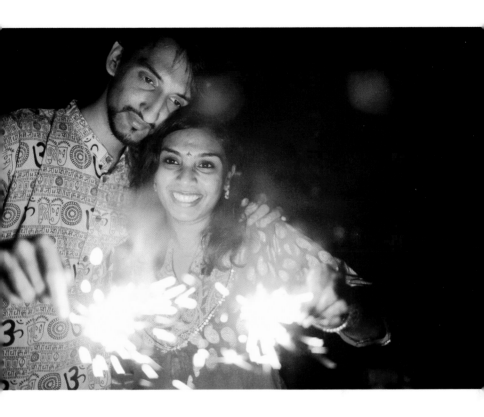

Grateful to shine light together on the path ahead.

KARTHIK NAGARAJAN & SARMISTA PANTHAM

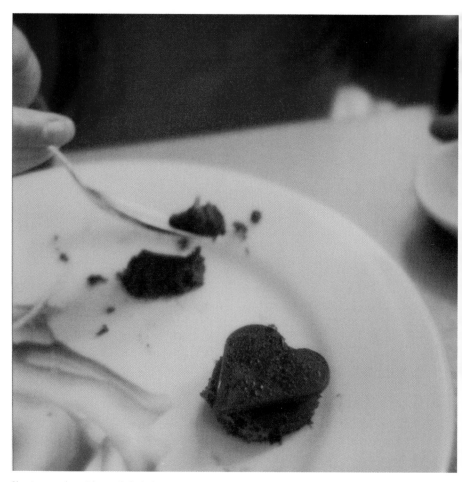

Sharing a cake with my little lady.

HAILEY

I am so grateful for the time my husband takes to be with his girl. He is a loving father who will give up an afternoon of serious fishing to bring joy to her little heart.

ANGIE KROEKER

Out with a ray of sunshine.

HAILEY

I am grateful for the gift of suffering.

Don't get me wrong, I do not ask for it—do not seek it out as a preferred modus operandi in my life. But when it does come, no longer can I hide behind my pretense of having everything "together," secure in my middle-class existence.

Suffering slices through the complacency, the manufactured *self* like a knife through butter; and I am forced to a screeching halt—to face a small *self* that is frightened, abandoned, and uncertain about who she is anymore.

It is then, and only then—when suffering surfaces—that I begin to grasp what really matters in this world. I am, once again, face to face with those whose very existence has no peace, harmony, or opportunity to even consider self-fulfillment. Those in war-torn countries, or devastated by natural disasters, or facing the grief of loved ones killed, or children abused, or personally starving, or maimed through forces they did not create.

Suffering knits and knots me to the plight of 98 percent of humanity, and I begin, slowly, painfully, to connect with that real me. And I don't usually like what I find. For behind that surface of respectability is a small, satisfied voice whispering to assure me that it's them, and I'm okay, so I don't have to get involved.

It is only as I enter fully that "dark night of the soul": not trying to avoid but instead seeking a way through, that I catch a glimpse—albeit dimly at first—that this, this, is what is real. All the other stuff, designed to keep me from facing reality, is just trappings.

I don't want to live entrapped. And so, painful as it is, these seasons of suffering are my teachers. They teach me about pain. They also teach me about love, about hope, forgiveness, wisdom, and acceptance. That I can act in the face of adversity for the greater good. I can learn, yet again, to be flexible, honorable, nonjudgmental and proactive.

I am a slow learner, for the lessons have to be repeated. And yet, because of the richness that she brings in and through this wonderful experience that is life, I embrace suffering, and am grateful.

ISABELLA CHRISTINE ERSKINE-SMITH

Grateful my husband still loves me, after seeing how I look during camping! If he doesn`t leave me now, he never will!

Grateful I'm going home from camping later this evening!

JANNE NORDVANG

Kids out this morning but these guys chase me around the
house and make me laugh with their high-speed running!

HAILEY

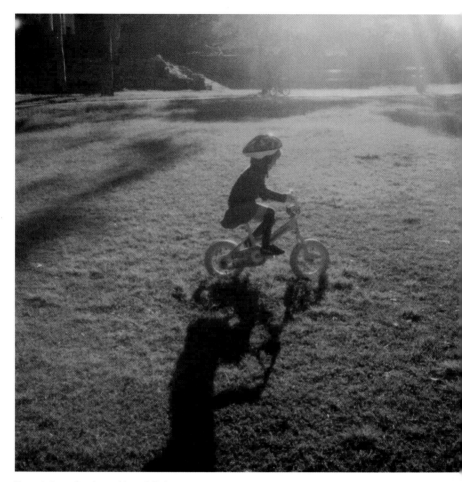

No training wheels, and her delight.

HAILEY

I am grateful for still being able to walk long distances, like the Rockland Breakwater... After a car accident about a year ago, and breaking two vertebrae, I'm amazed at how the body can heal!

MICHELLE CHRISTIAN

While I was looking through pictures that I have taken over the years, my tabletop became very cluttered. Much to my amazement, I found some old treasured family pictures. I was so grateful because I thought they were lost. The little girl on the pony on the bottom left is me.

MADELINE JAROSCH

I love all they are learning and enjoying from having pets.

HAILEY

My brother who made me a veggie garden and for friends who enjoy kids and gardens and chickens and music and play and health and sunshine and rain and friendship and work and community.

HAILEY

I took this picture from out my kitchen window. I'm lucky and grateful to be living in Taos, New Mexico!

CATHY MEI

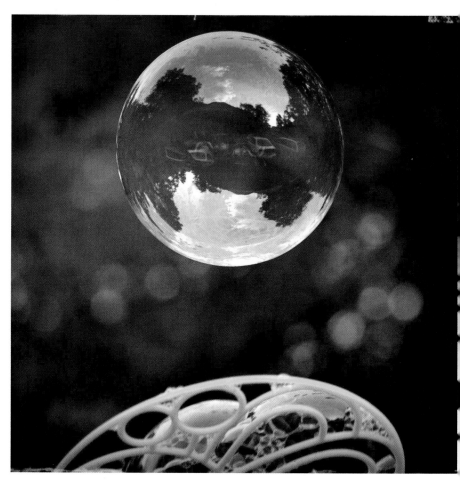

I'm grateful for bubbles. They bring out the inner child in us.

NANCY ROBISON

Grateful to take that quiet moment and to enjoy the beauty that life gives us every day.

DIANA SAINZ

"And just say yours loves to eat pandas!"

HAILEY

I'm grateful for local fireworks displays that I always love to see.

DAWN SWINGLE

I'm not a big fan of fall at all, but being able to go out, relax, and take a few pictures like this, it's a big thing to be grateful for sometimes.

MARIA LOPEZ

I feel so lucky to have access to organic food!
I love it when the bowl is full.

HAILEY

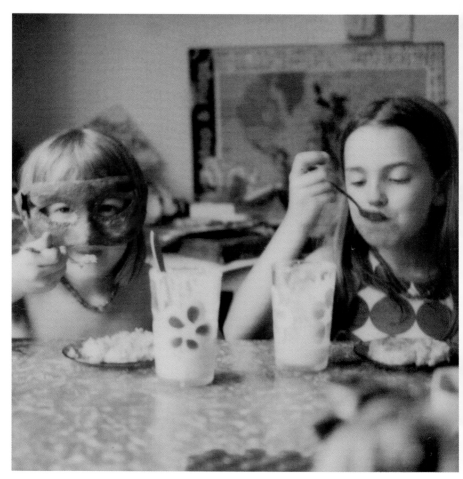

At home eating a yummy lunch and just
hanging out. I love to relax together.
HAILEY

On my birthday, I took myself out for a special black raspberry
chocolate chip frozen yogurt. With chocolate sprinkles.

JEANNE LAPIERRE

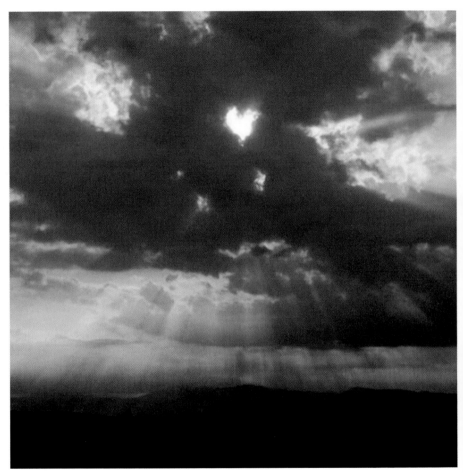

I saw this on my parents' anniversary (my dad passed away years ago). I think it was his way of saying he loved and missed us. I'm eternally grateful for little signs such as this.

ALLISON LEACH

I am grateful to be alive! Went for a walk in the cemetery…
Such a beautiful day. Such amazing trees. Blue, blue sky.

HAILEY

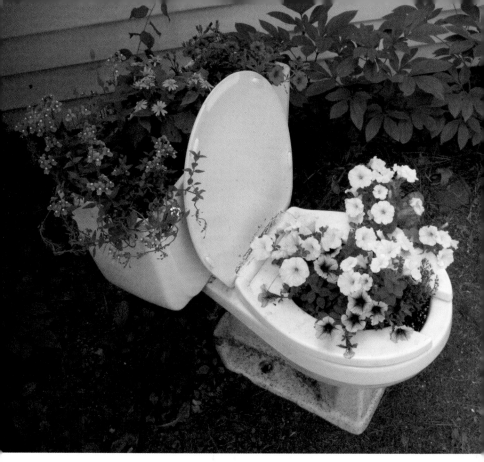

Our old toilet. My husband wanted to plant flowers in it, so I did, and here is the result. It had rained heavy, so it's mud splattered, but I'm just grateful that we could replace the thing and have fun with the old one. Lots of people who visited us had a good laugh, and there's nothing more rewarding than making people laugh!

DIANA SIMS

We had to make the hardest decision of our lives this year. We uprooted our family of five, sold our house, and left all our beautiful friends, our close-knit family, and the great friends our three children had made over the years. It was heartbreaking but we had to follow where the work was and start our lives in a place where we didn't know anyone.

I am therefore ever so grateful for the humble telephone. On days when I feel so sad and lonely, the phone will ring and I will hear my mum or dad's voice, or one of my many sisters telling me stories and brightening my day. I love that I can just pick up the telephone and hear all the news from my friends and what the local gossip is.

The telephone can always hide a tear that trickles down my face as I tell my mum that everything is great and I'm happy about the move. There is nothing like hearing a loved one's voice on the other end of the phone to make everything okay.

Every day is getting easier, the children are making friends, and life is good.

Life would be a lot harder right now, however, without the telephone. So thank you, telephone!

SHELLEY COTTER

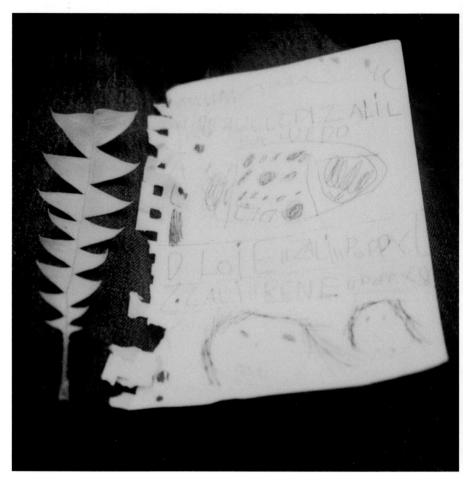

Amazing leaf from a banksia and a hilarious drawing by Poppy.

HAILEY

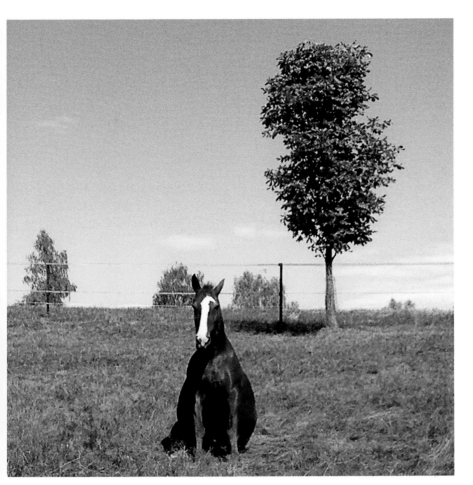

Where is Lucky Luke? At twenty-three years of age my Ronja sometimes
needs a break! I am grateful to own such a loyal soul of a horse.

KERSTIN KRAUSE

This is a picture of the snow at my school. I am grateful because this is the first time in my life I have experienced snow and I had an amazing day surrounded by friends.

MICHELLE GERSBACH

I am forever grateful I didn't have $18 in my purse the day the ob-gyn wanted to do a test for birth defects. I played a part in shaping who this incredible young man turned into, touching hundreds of lives along the way. I will be grateful when I get to hold him in my arms again, and am grateful now, that my mother is holding him in hers until I get there.

SHAW LAMB

Nonstop chatter. A dear friend and so much fun
to have a day away from everything.

HAILEY

As someone who has been the victim of credit card fraud, I am thankful for my shredder. I get to destroy unwanted credit card applications, paid bills, old bank statements, and, best of all, create more recycling. Plus, there is a sense of accomplishment when I see a full bin.

KAREN GUENTHER

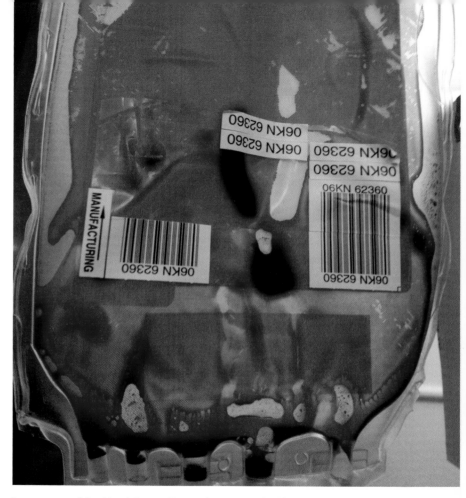

I am very grateful to blood donors. I have aplastic anemia and get blood transfusions every two weeks. These anonymous donors keep me alive and I am so thankful for their generosity.

PAM MUZYKA

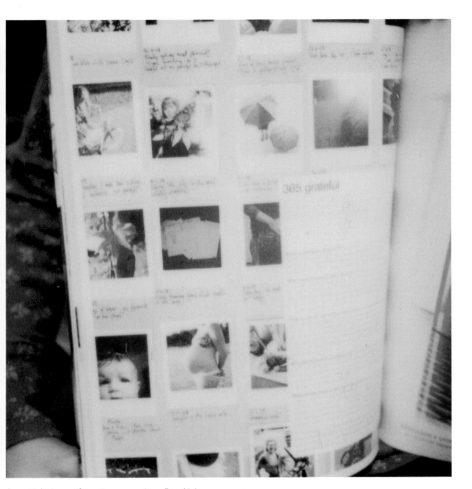

365 grateful

An article in my favorite magazine, *Frankie*!

HAILEY

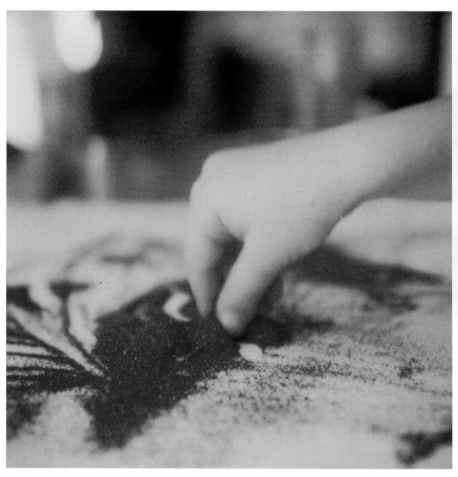

Now they are home more and there is so, so much
more mess. But my heart is grateful and at rest!

HAILEY

I am grateful for my father's life and our wonderful friendship. After he was airlifted to the hospital in December 2010, I was told my father suffered from a blown valve, an aneurysm, and a torn aorta of the heart. They would attempt surgery, but had never done a surgery like this and he would most likely die. Being told at sixteen that I should start preparing my father's funeral arrangements was the worst thing I had ever been told. Even worse than when my mother left us. My dad has always been my very best friend. Not many people get to experience such a close, genuine relationship, and being told it would probably come to an end was a terrible experience. But I believe that due to a whole lot of prayer, my daddy survived and came home two days before Christmas (when he should've been in hospital for another month), and we got to spend Christmas morning together, when this photo was taken. I realize every day how grateful I am for his presence in my life and for everything he has done for me.

ERIN WELLS

sweet oNes

I called Brenda in tears—several times. "He growls at us. And he lunged." Brenda was the president of the Greyhound Association where we adopted our beautiful rescue dogs,

Mia and Mason. At first, Mason was scared, cautious, and unable to trust us. Brenda assured me that he would adjust in time. She was right.

LORI PORTKA

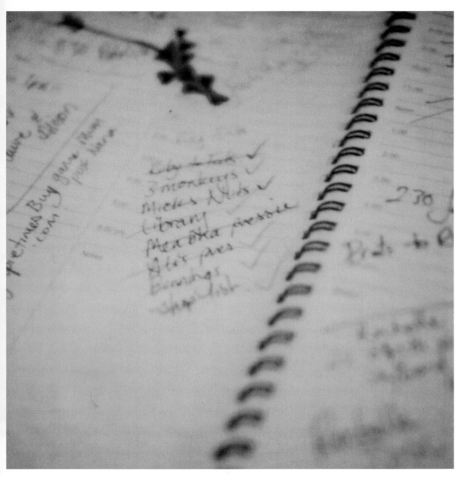

A list of jobs completed. Very satisfying!

HAILEY

Sick but so fun when you have lovely children
who play happily and a great book to read.

HAILEY

Grateful for magical gifts from my children.

DEB SCHWEDHELM

I'm grateful for good genes! While going through my mom's effects last summer, we found these two photos… both of us are fourteen years old here. I'm guessing that she brought the right baby home from the hospital.

JO IN NJ

Home in our yard and the outfits come out… along
with dance and drama from this little miss!

HAILEY

Even when I insist he puts on a tutu for a photo, he is so very amazing and does it even though he doesn't really want to!

HAILEY

My daughter carries me and my husband around in her heart.

RIVKA FARCAS

Thankful I still know that no matter how much of a circular journey my life is taking me on—spinning me round and round in seemingly endless circles—sometimes one of those circles is in the form of the Ferris wheel in Toys R Us, and the only choice is to hop in the Monopoly car with carefree abandon, and let it take me for a ride!

JANELLE GLICKMAN

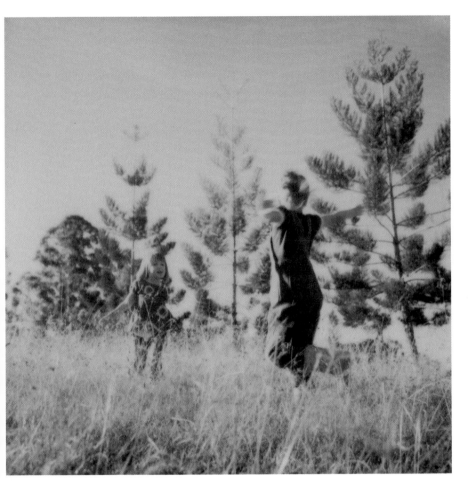

This field outside my parents' property…

HAILEY

Making wishes in the backyard with two little lovelies.
They wished for me to jump on the trampoline with them!

HAILEY

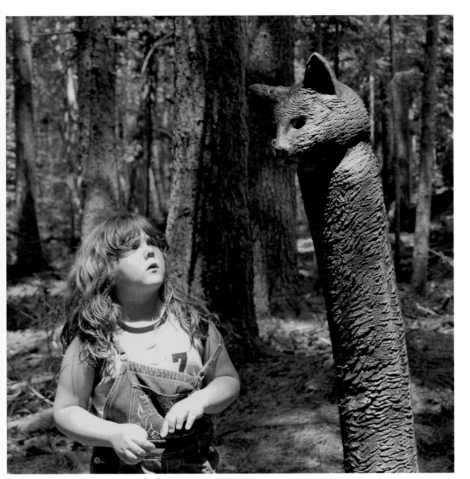

I am grateful for art... statues and carvings too... but Lily was a little surprised at finding this one (in the middle of the woods) on one of our nature hikes.

MICHELLE CHRISTIAN

He wrote me this message just when I needed it most.

XANTHE BERKELEY

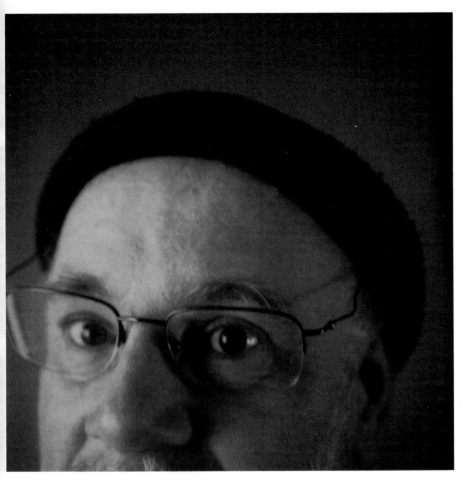

My dad. Who lets me make films of him and is funny.
And the kids just love him.

HAILEY

Our first bumper crop of carrots! The girls eat them anyway!

HAILEY

My grandad and his best friend came from Denmark to Norway in 1950 looking for work. Grandad married the love of his life; his friend went back to Denmark. They went to visit each other twice every year, called once a week, and became each other's second family. When my grandad was dying last year, his friend came all the way from Denmark to sit by his side. I'm grateful for friendships that last a lifetime.

JANNE NORDVANG

I'm grateful we live in a place where, at the turn of a knob, clean water pours from the tap. At any given moment we can step into a shower and clean our bodies. We can drink to our hearts content, which is good because we can't live without it. Water, being so readily available, we take it for granted. I think a day will come when we will want for this, and not realize what we had.

NANCY ROBISON

Pie for dinner, and my love gave me the piece with the yummy crust! I do rather like how kind he is to me!

HAILEY

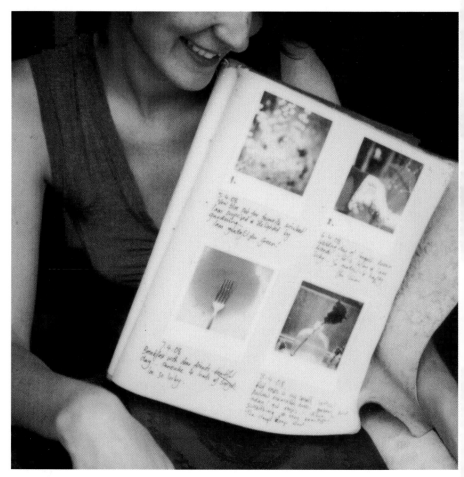

One whole year with this project. I am so proud I completed it,
and so, so, so grateful for all it has taught me!

—HAILEY